Adult Coloring Book
Queen of Enchanted Fantasy
Gothic Tales of Horror and Women of the Magical World

By Peaceful Mind Adult Coloring Books

Copyright © 2016

All rights reserved. No part of this publication may be reproduced, distributed, or transmitted in any form or by any means, including photocopying, recording, or other electronic or mechanical methods, without the prior written permission of the publisher

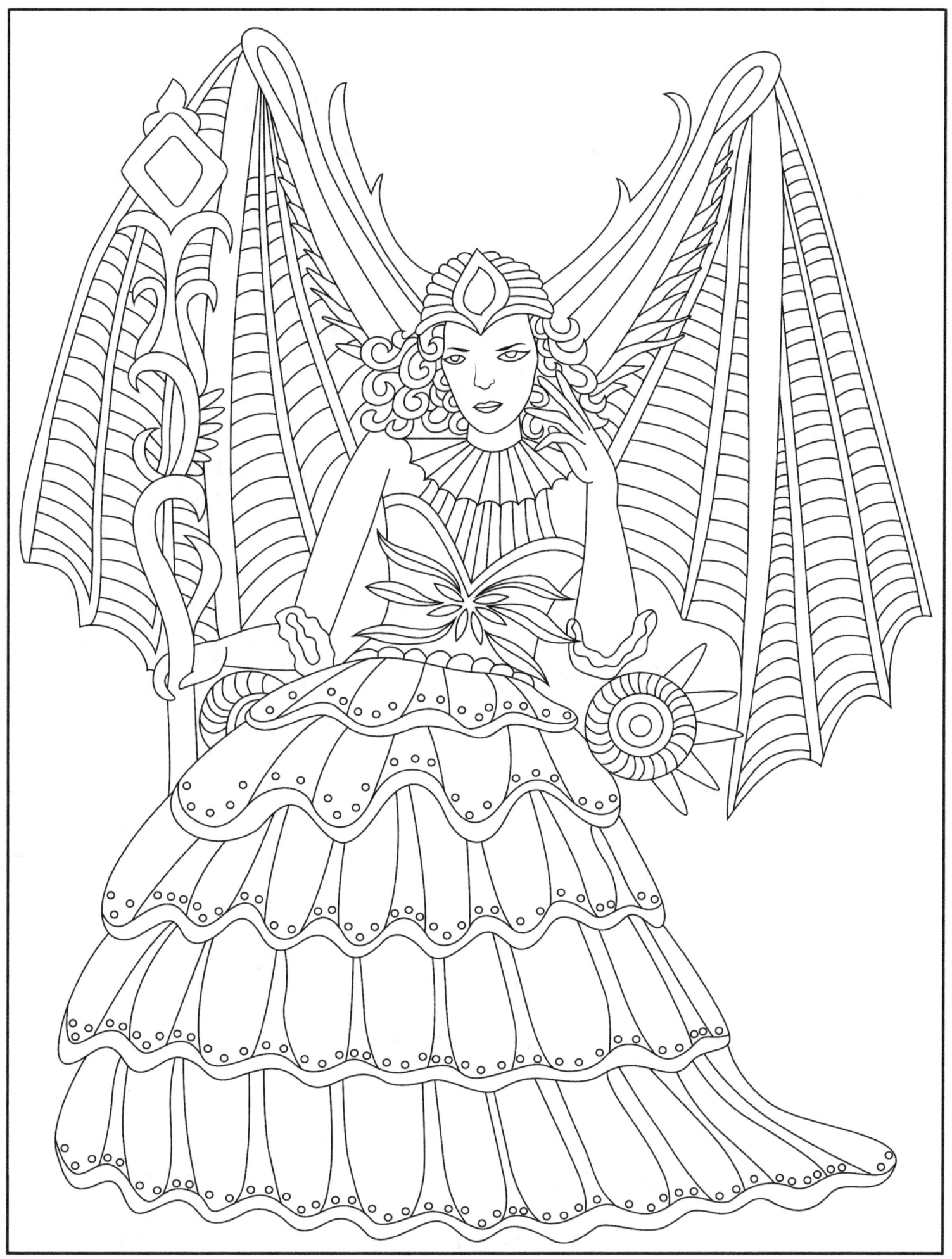

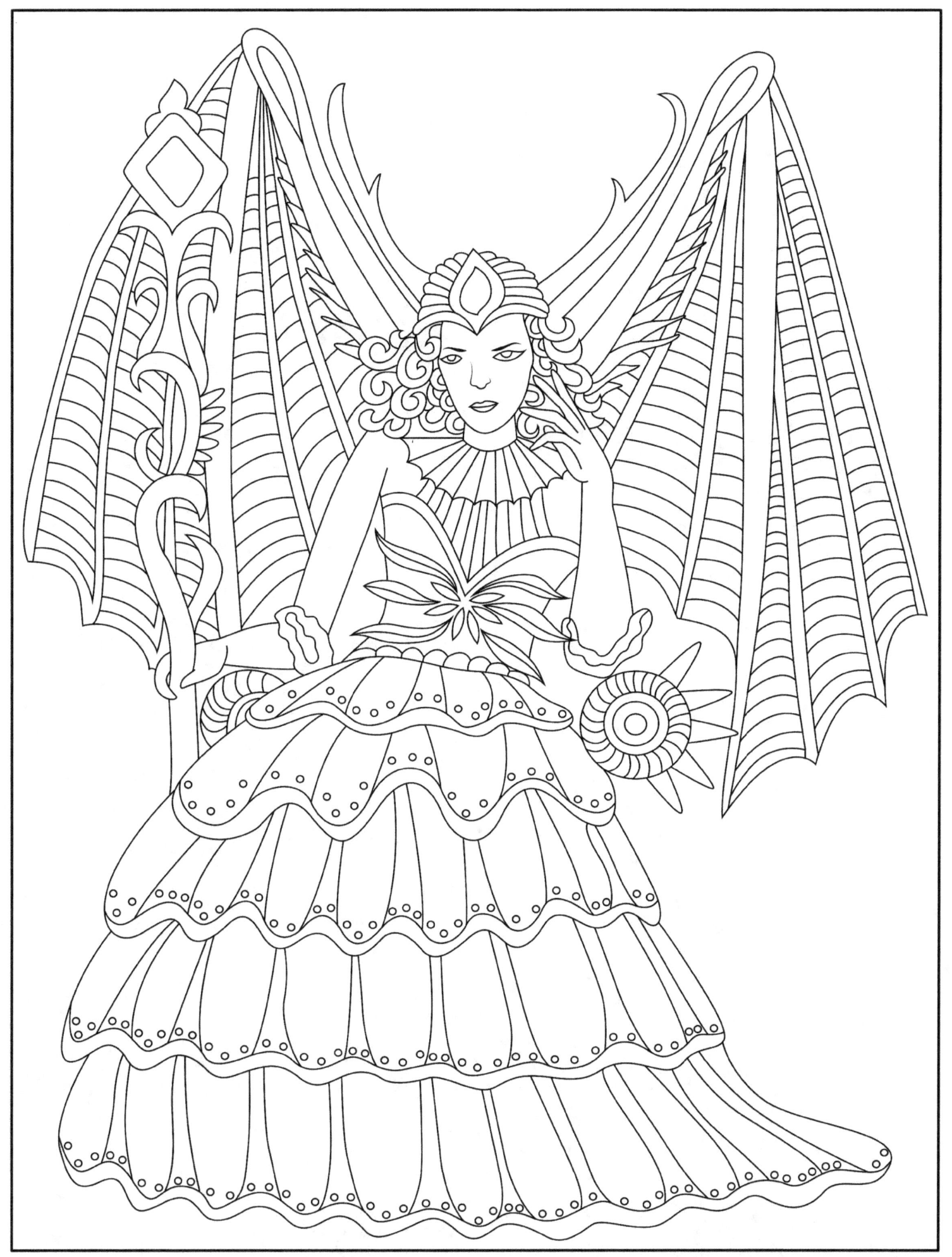

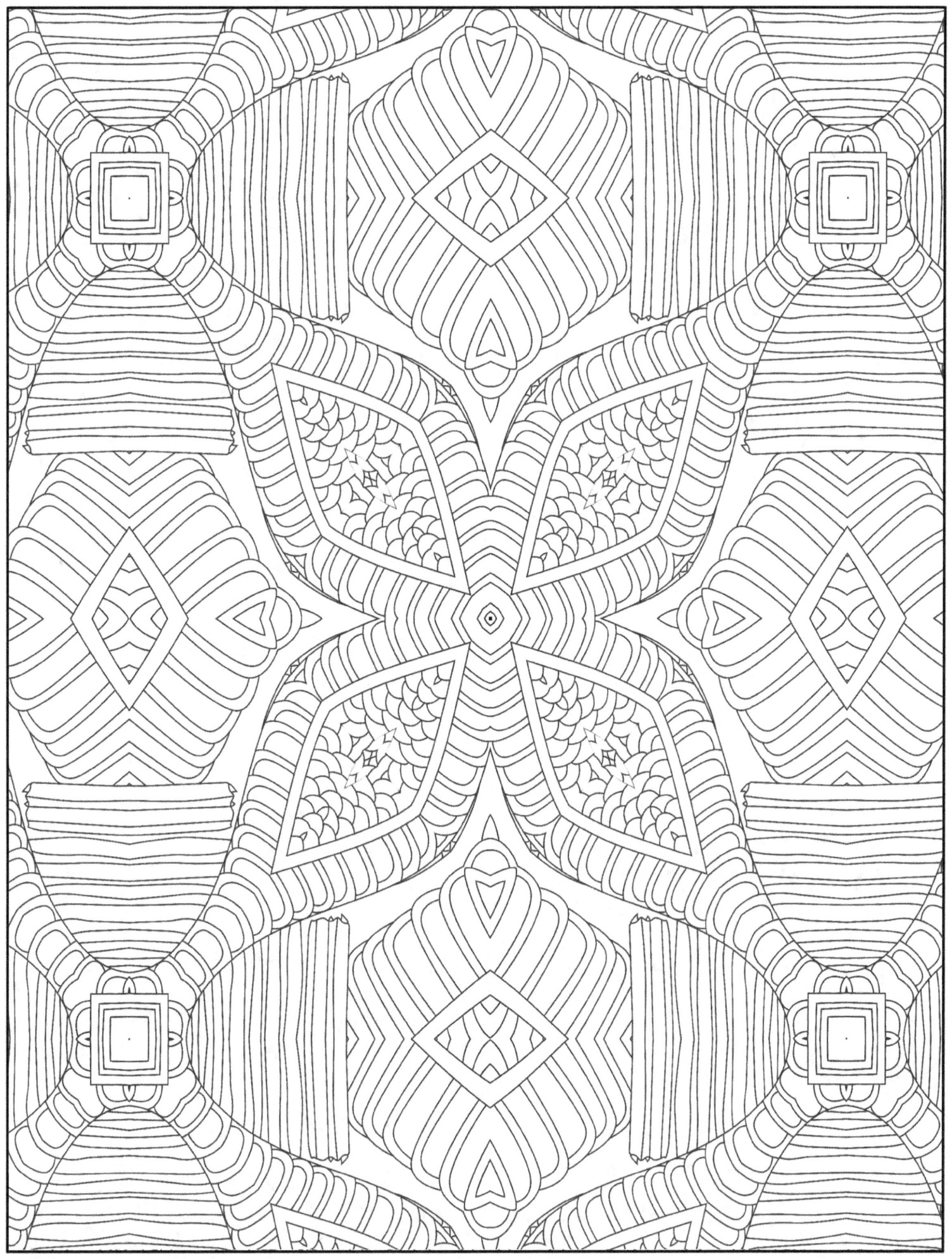

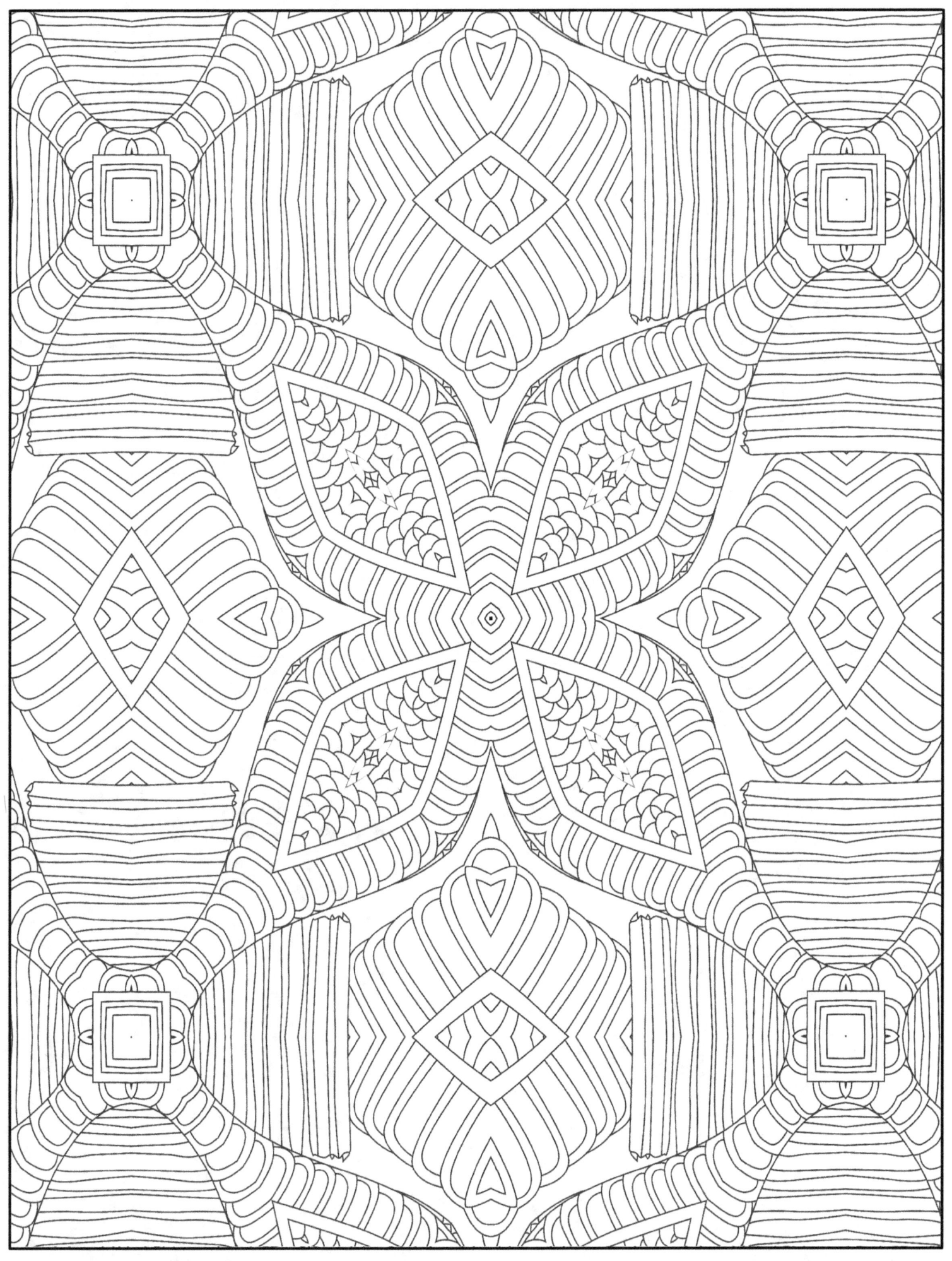

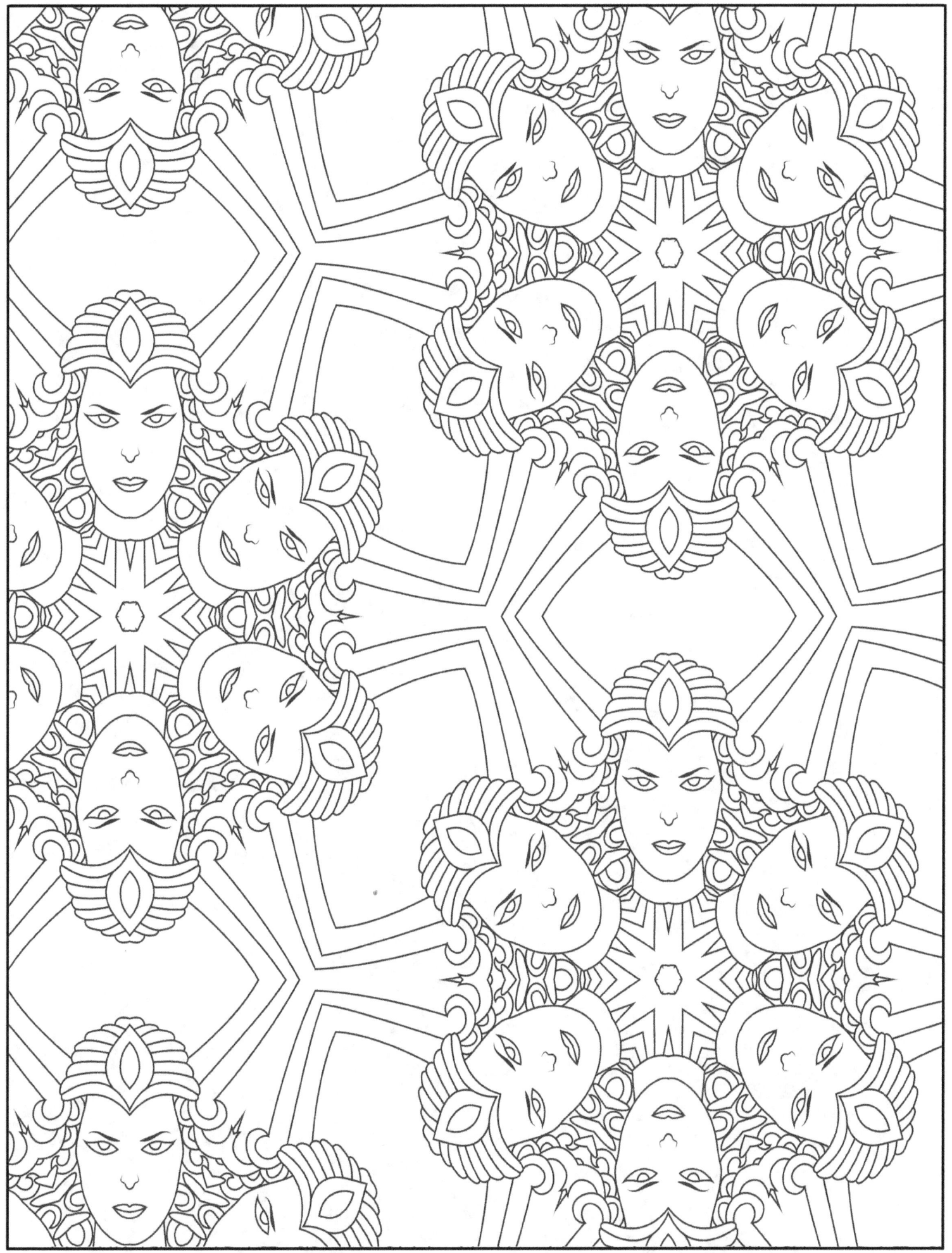

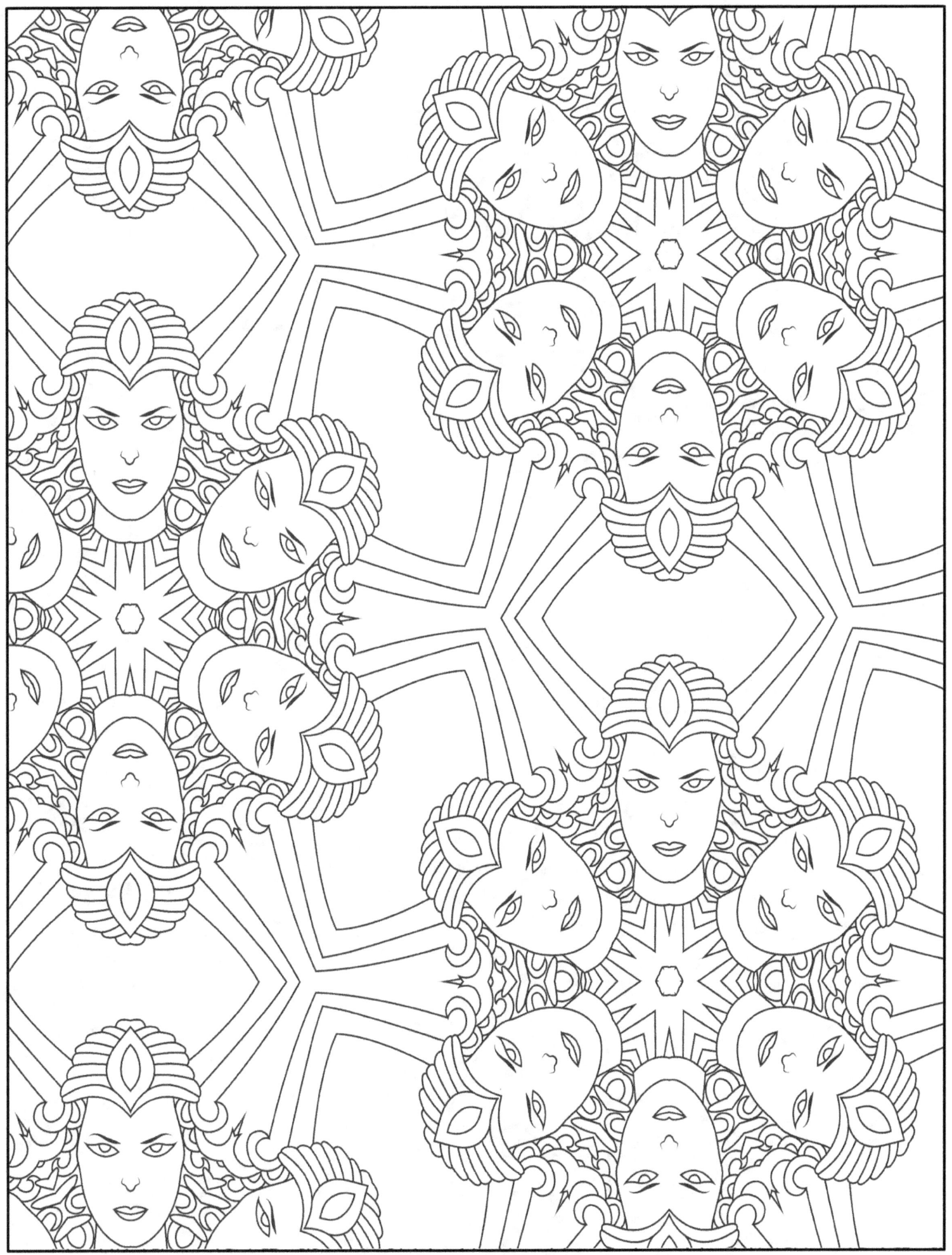

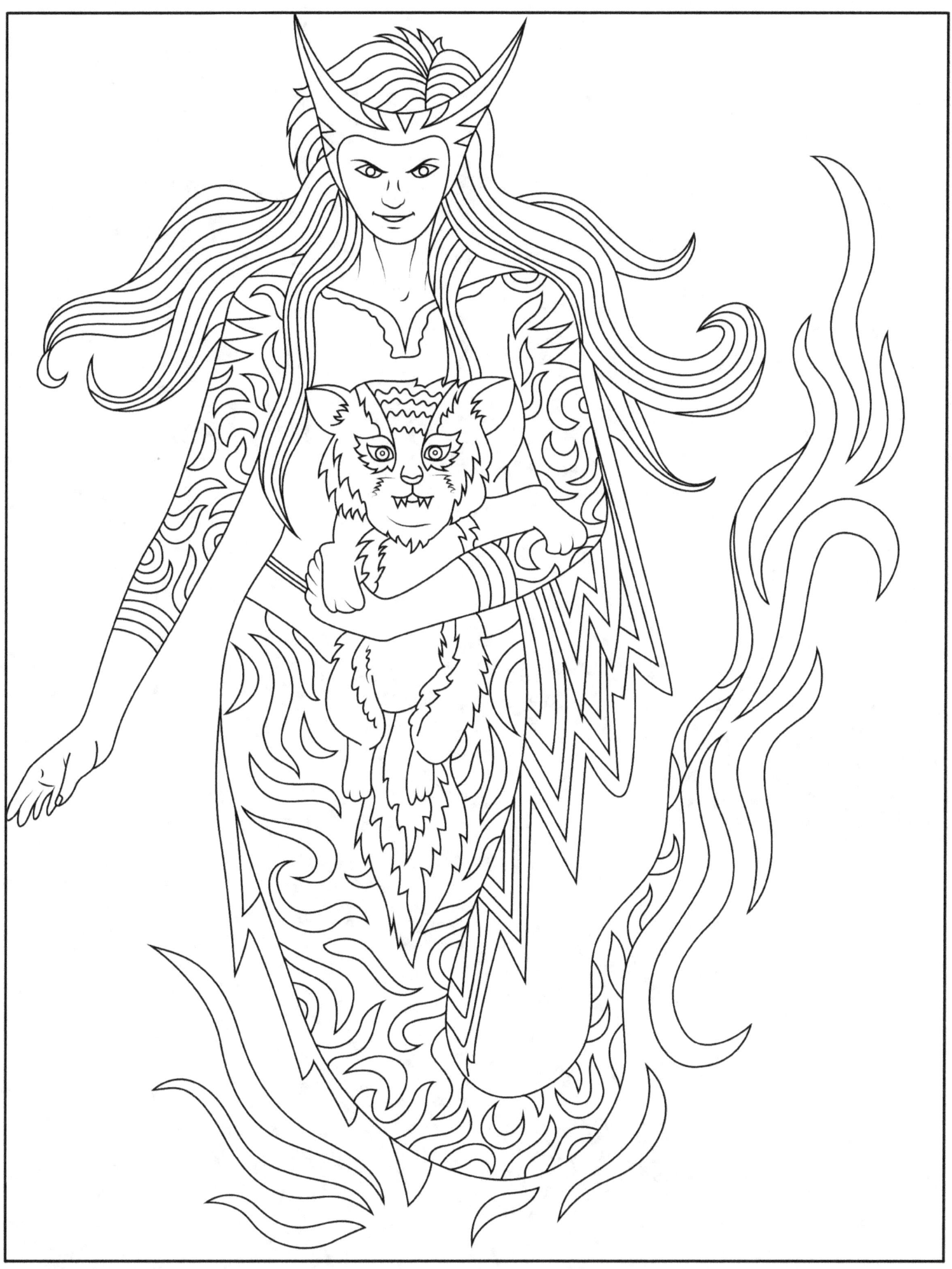

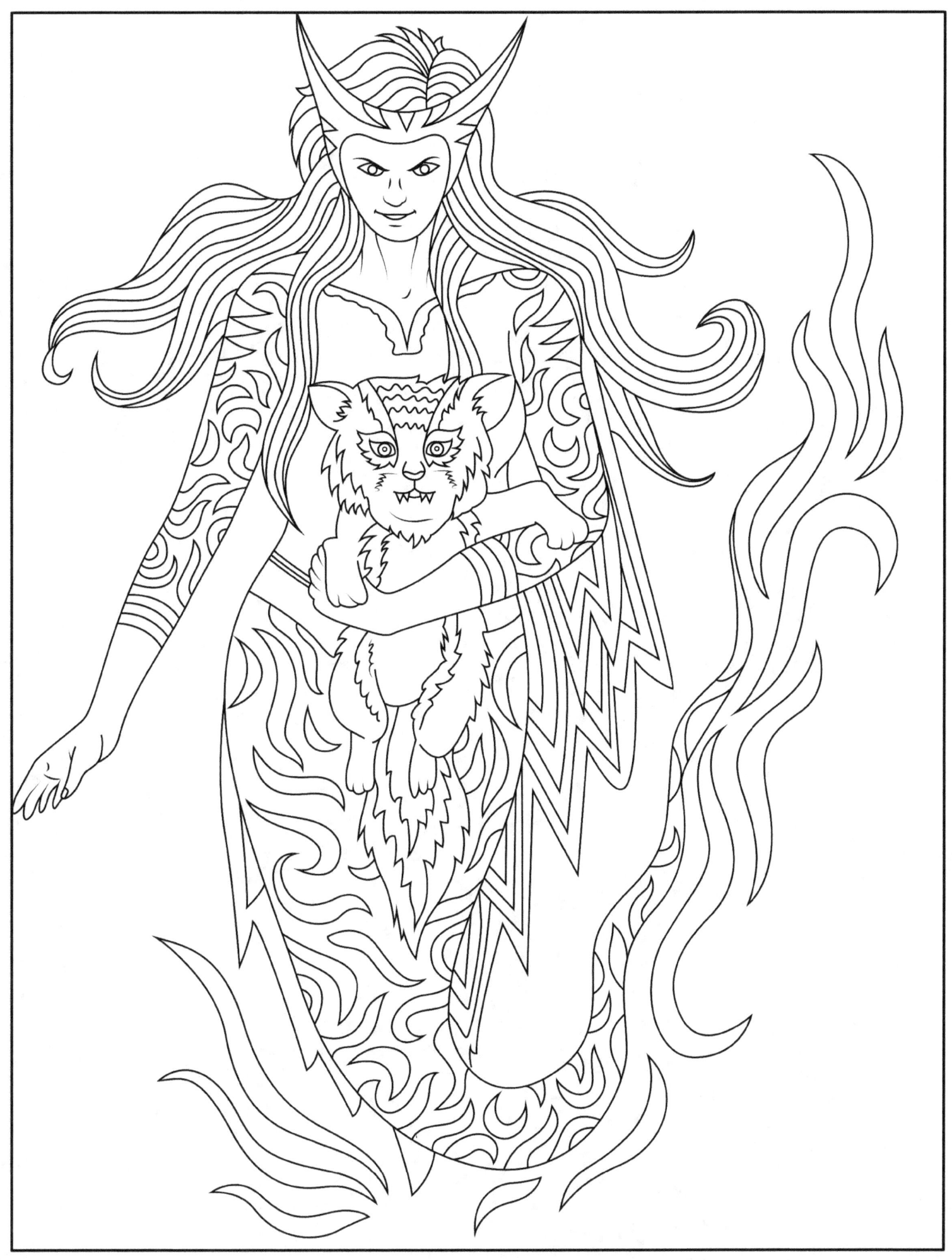

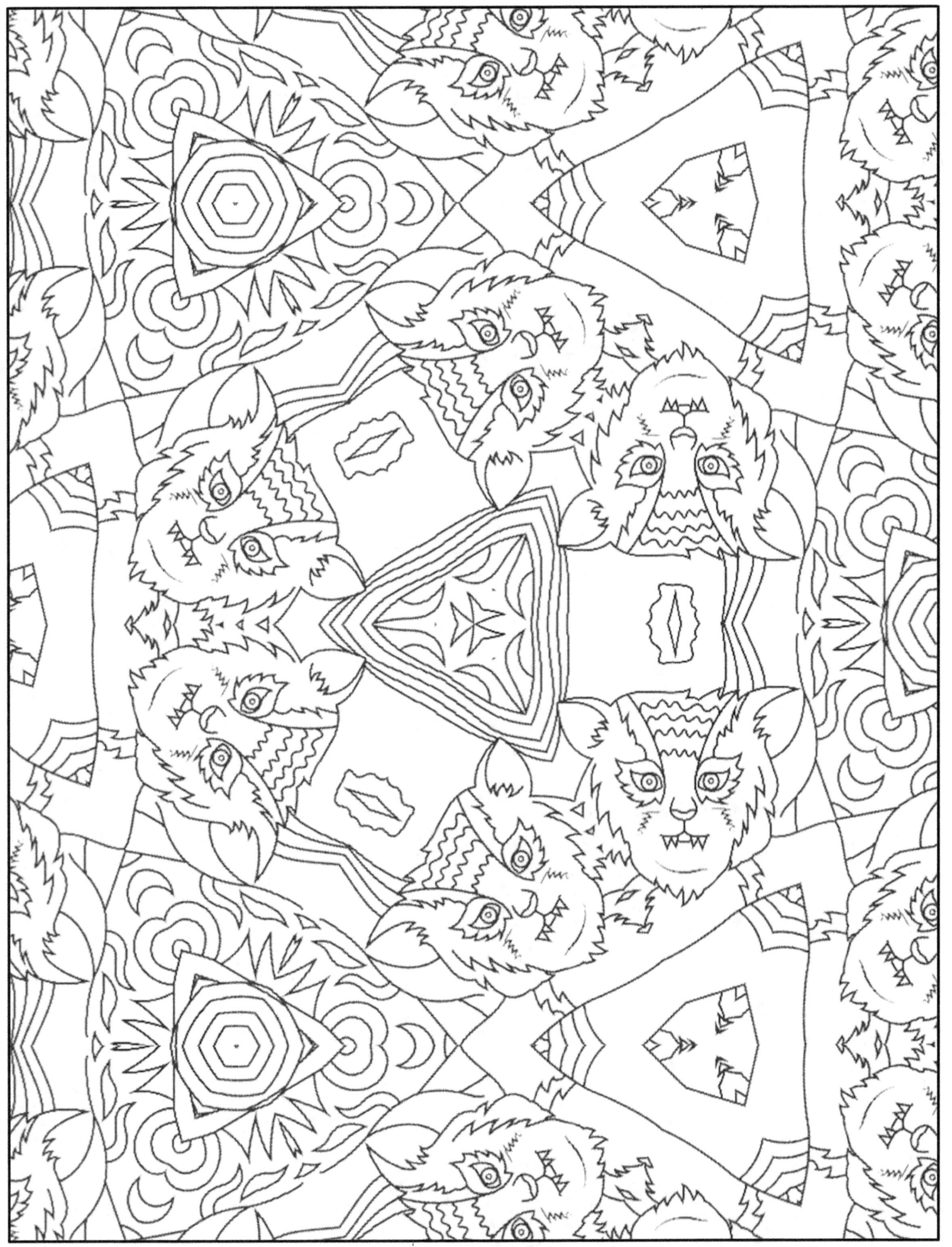

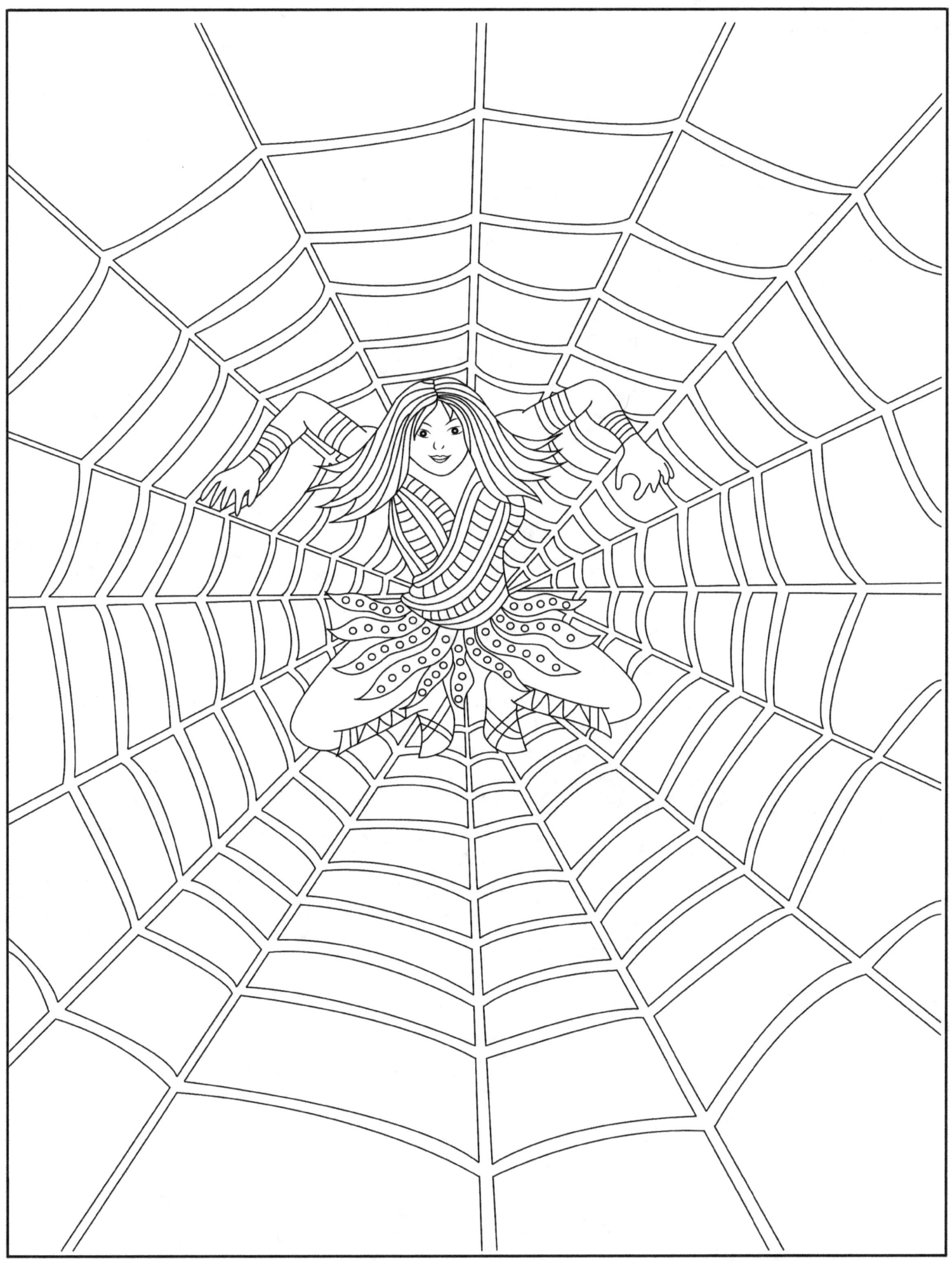

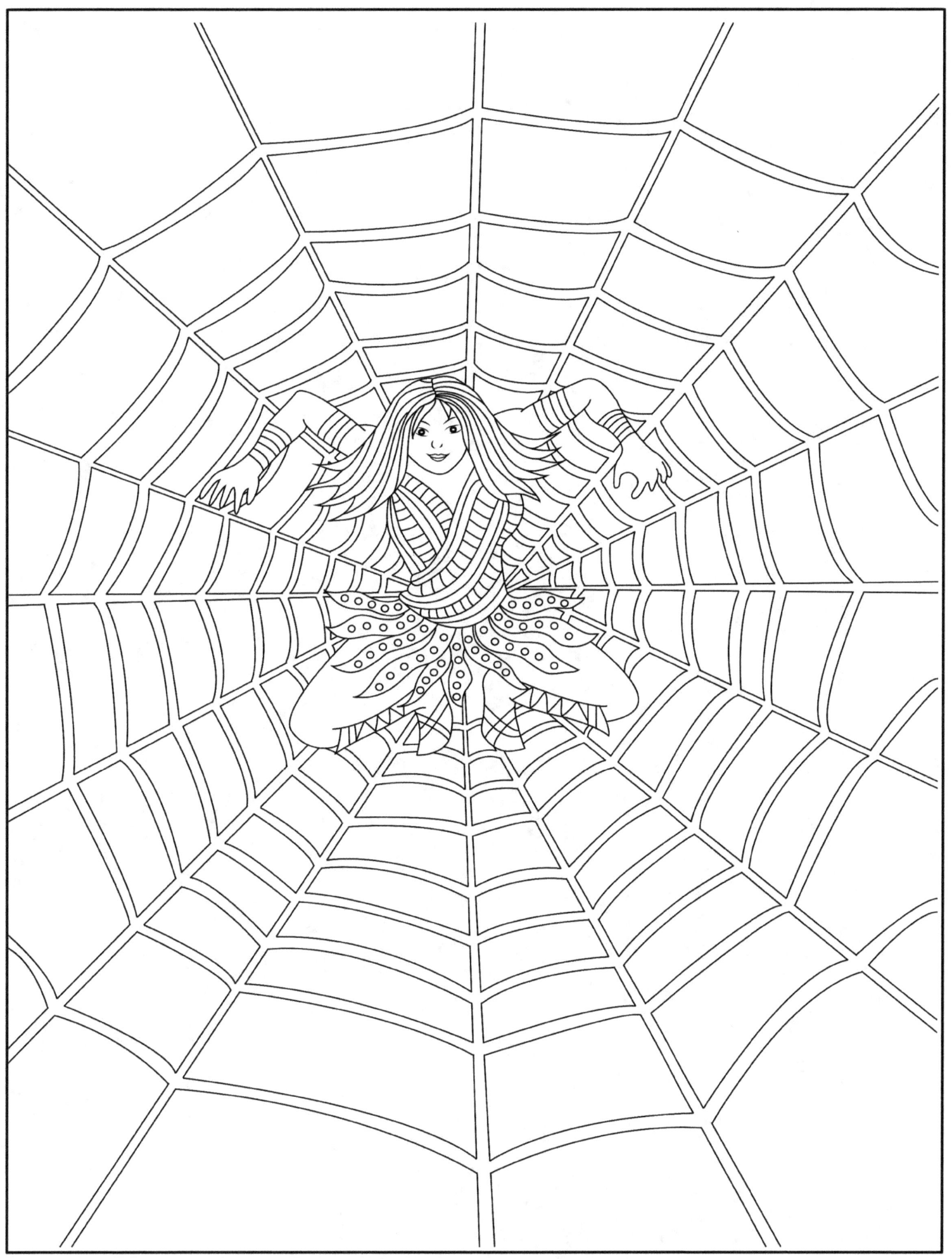

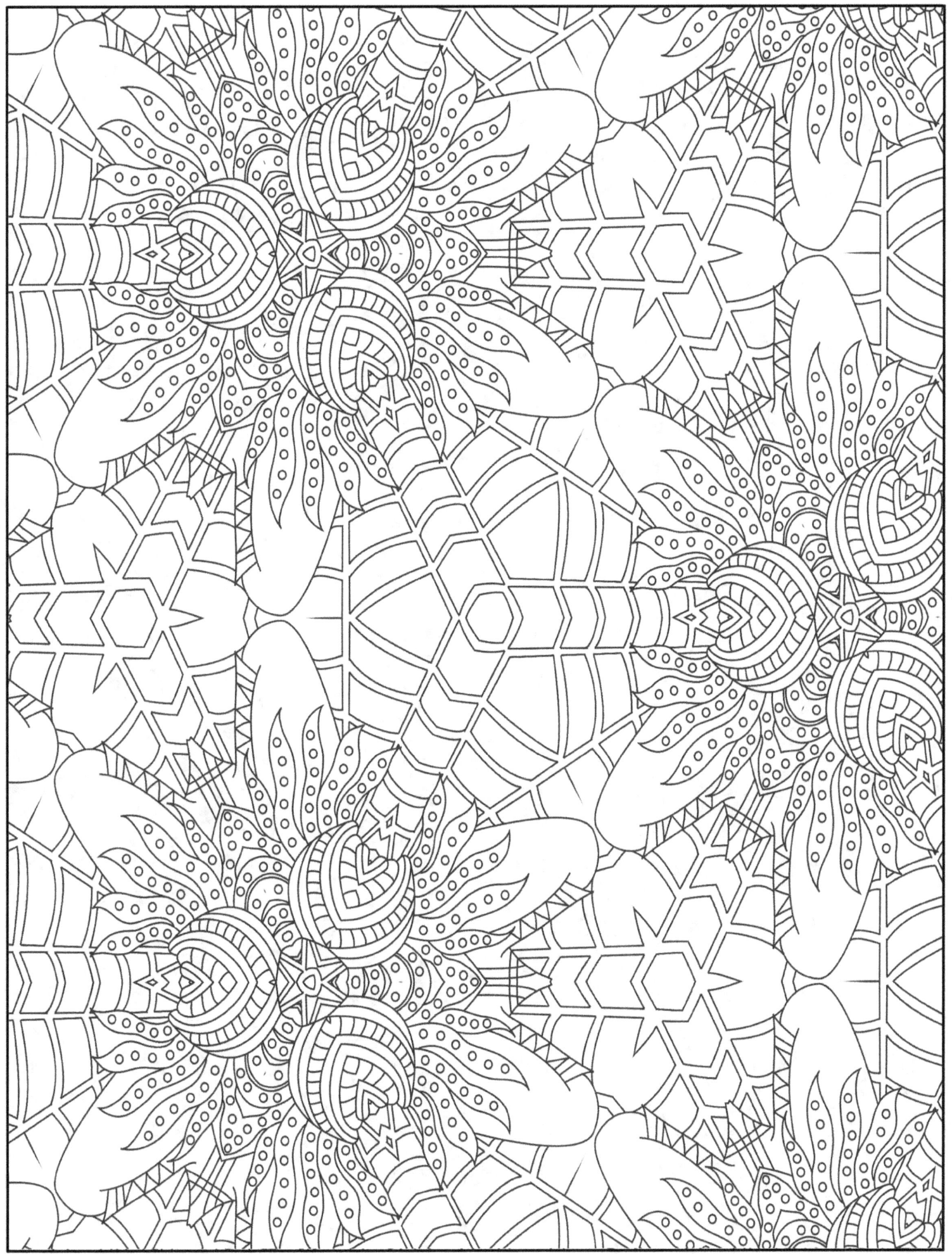

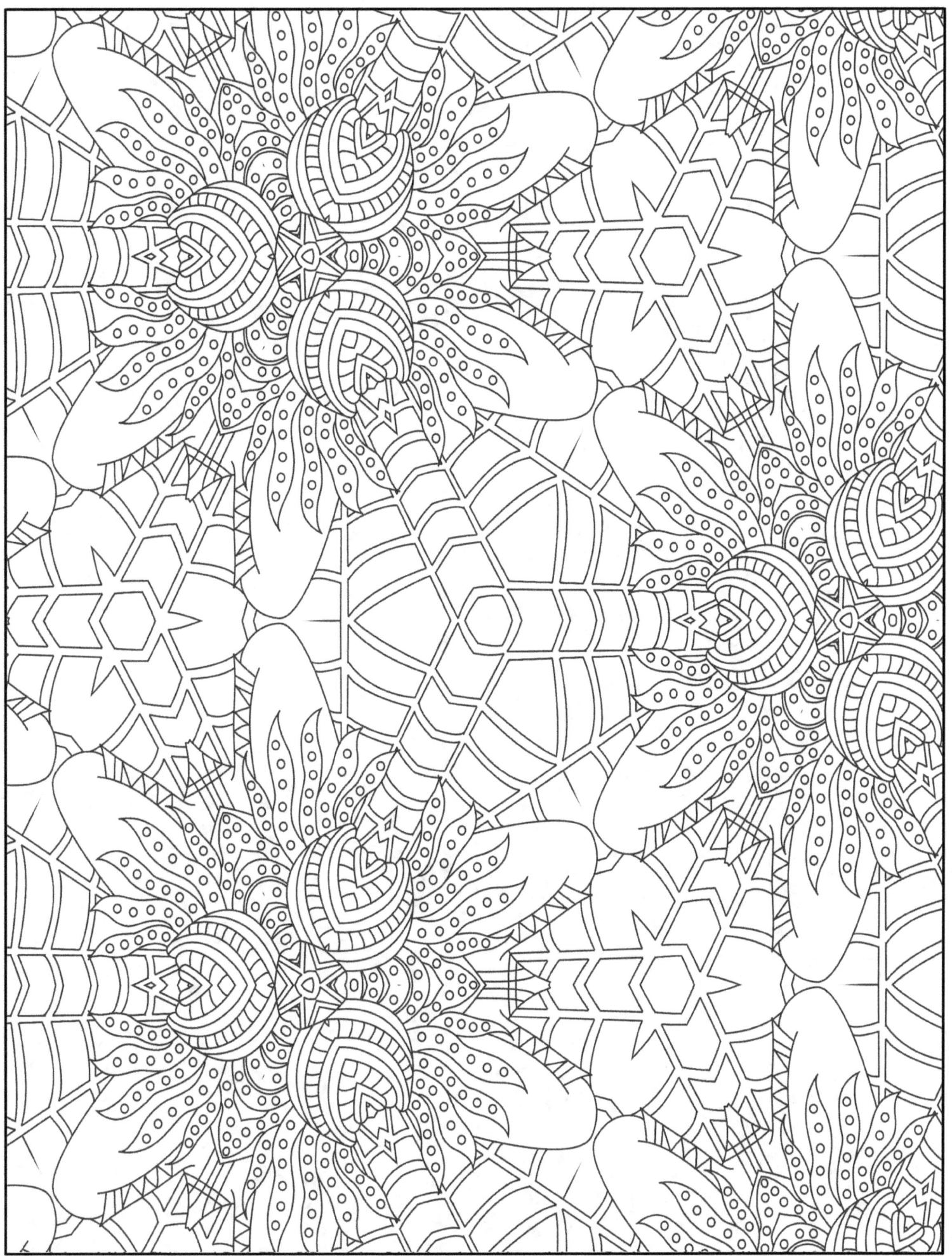

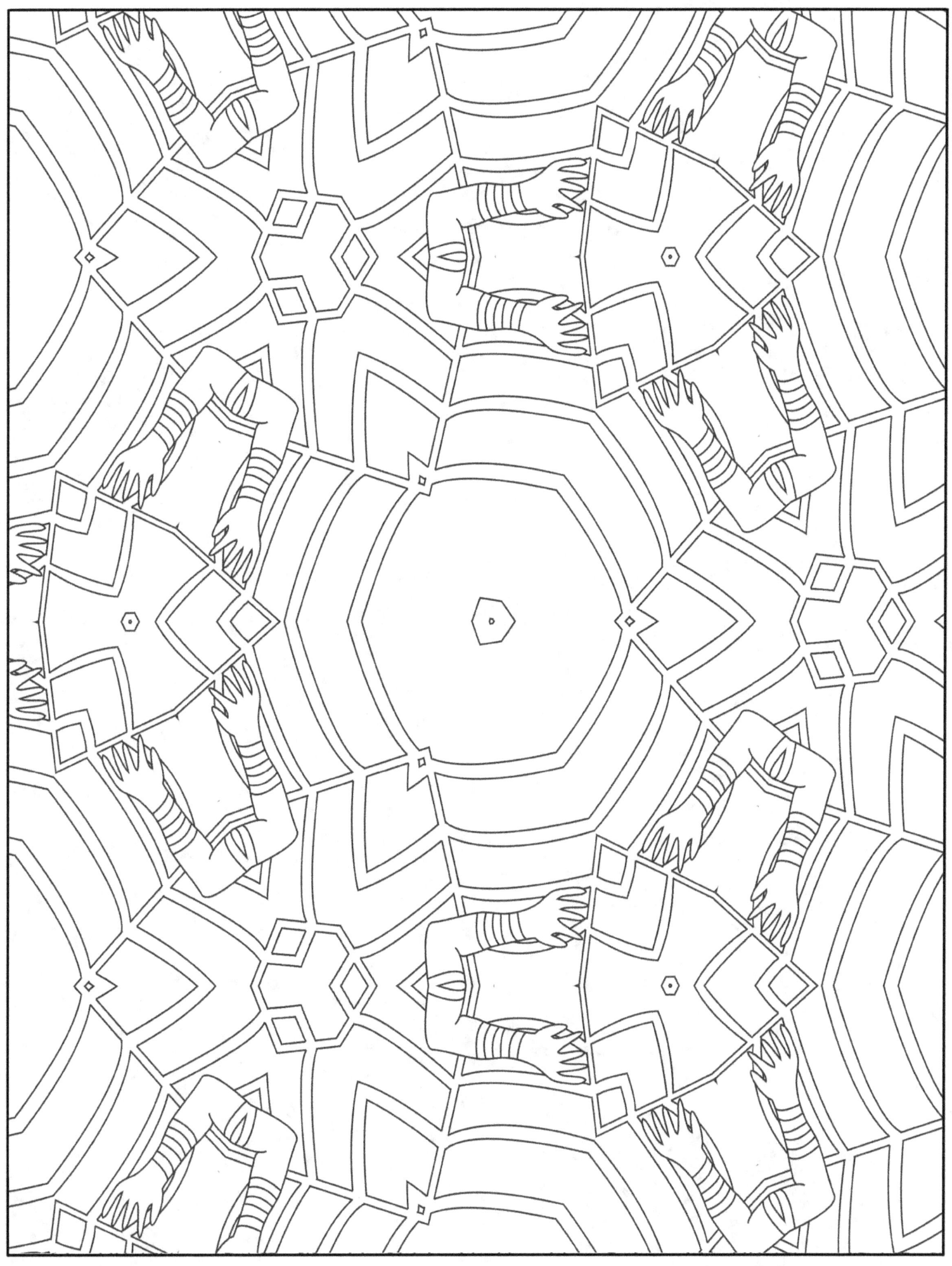

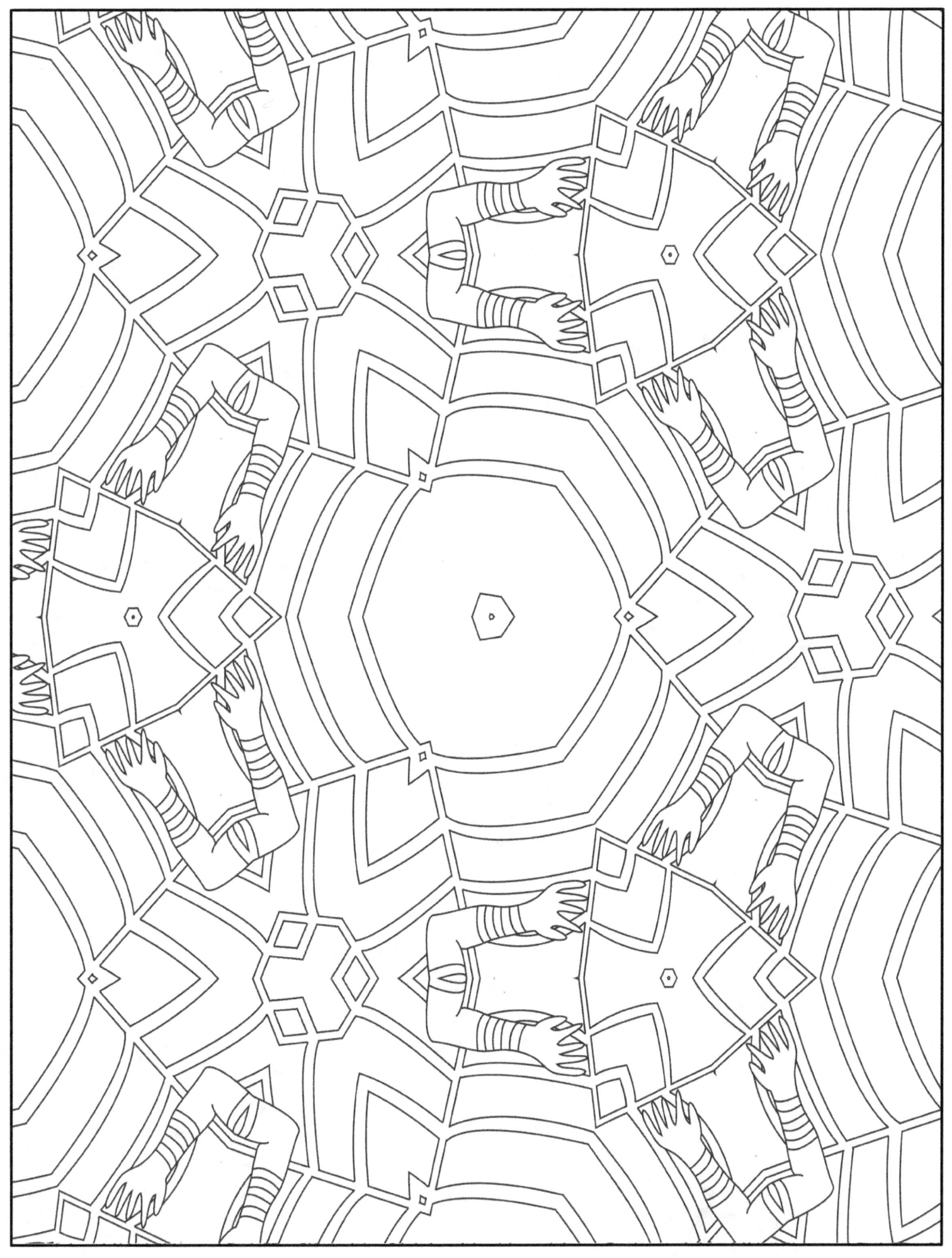

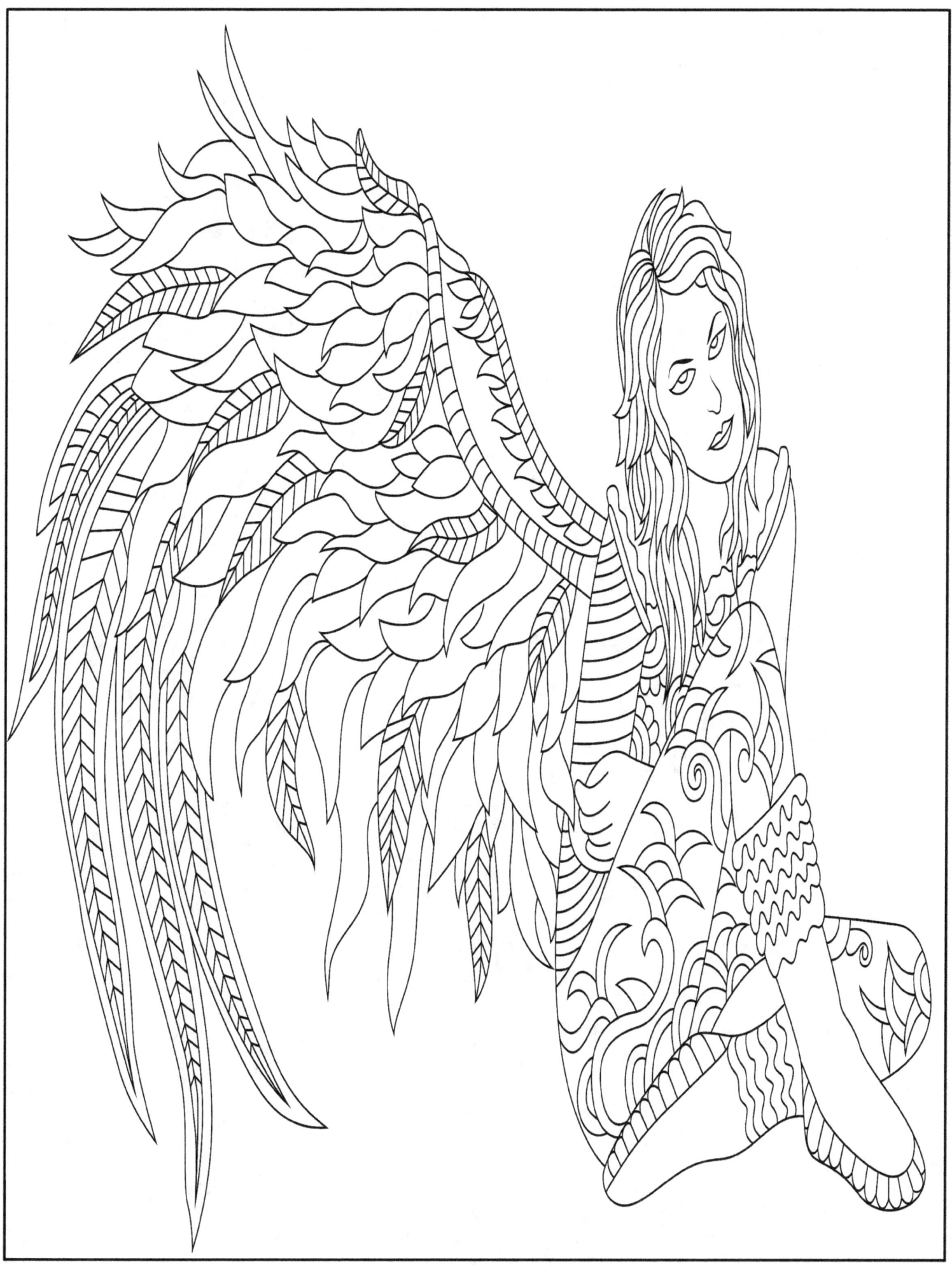

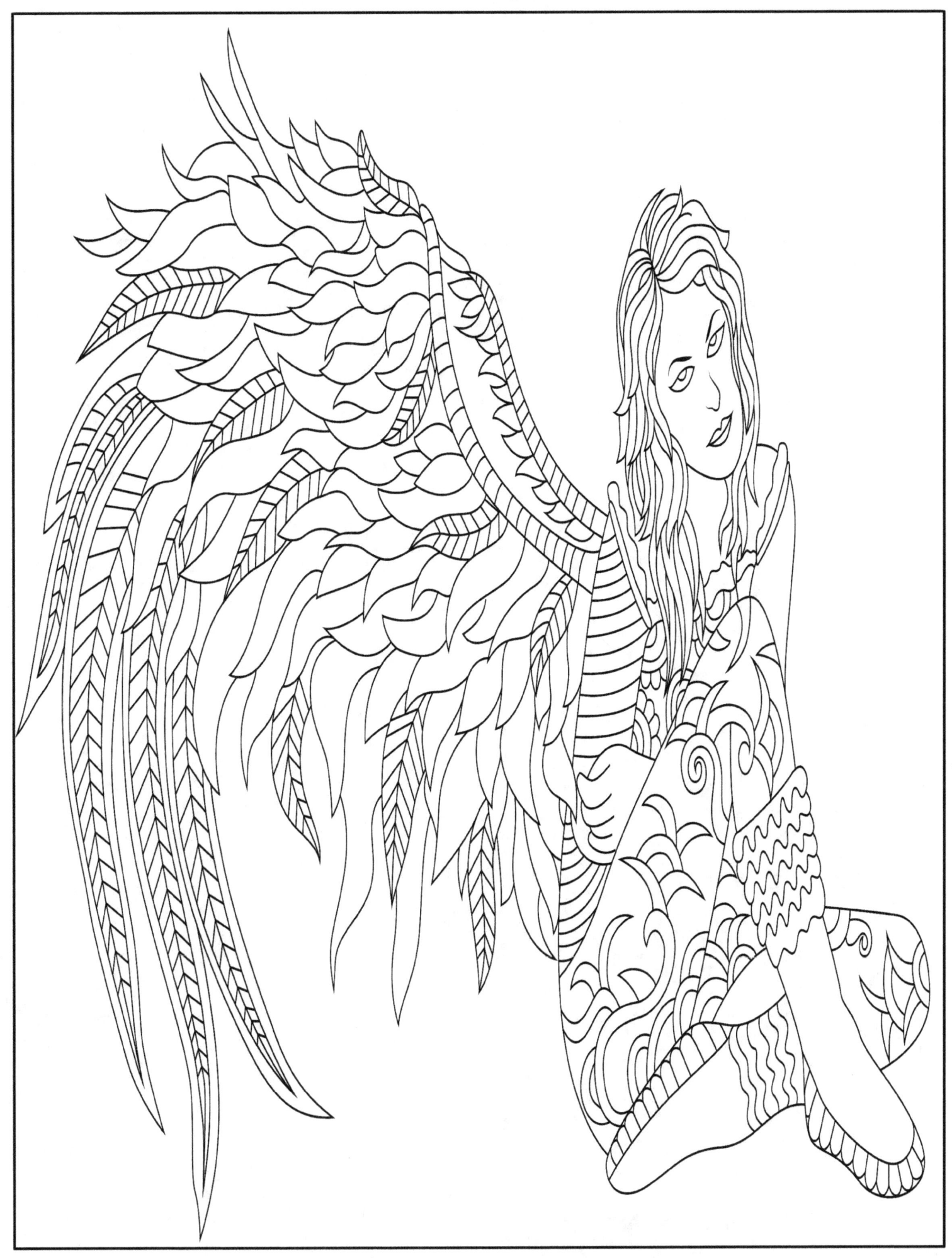

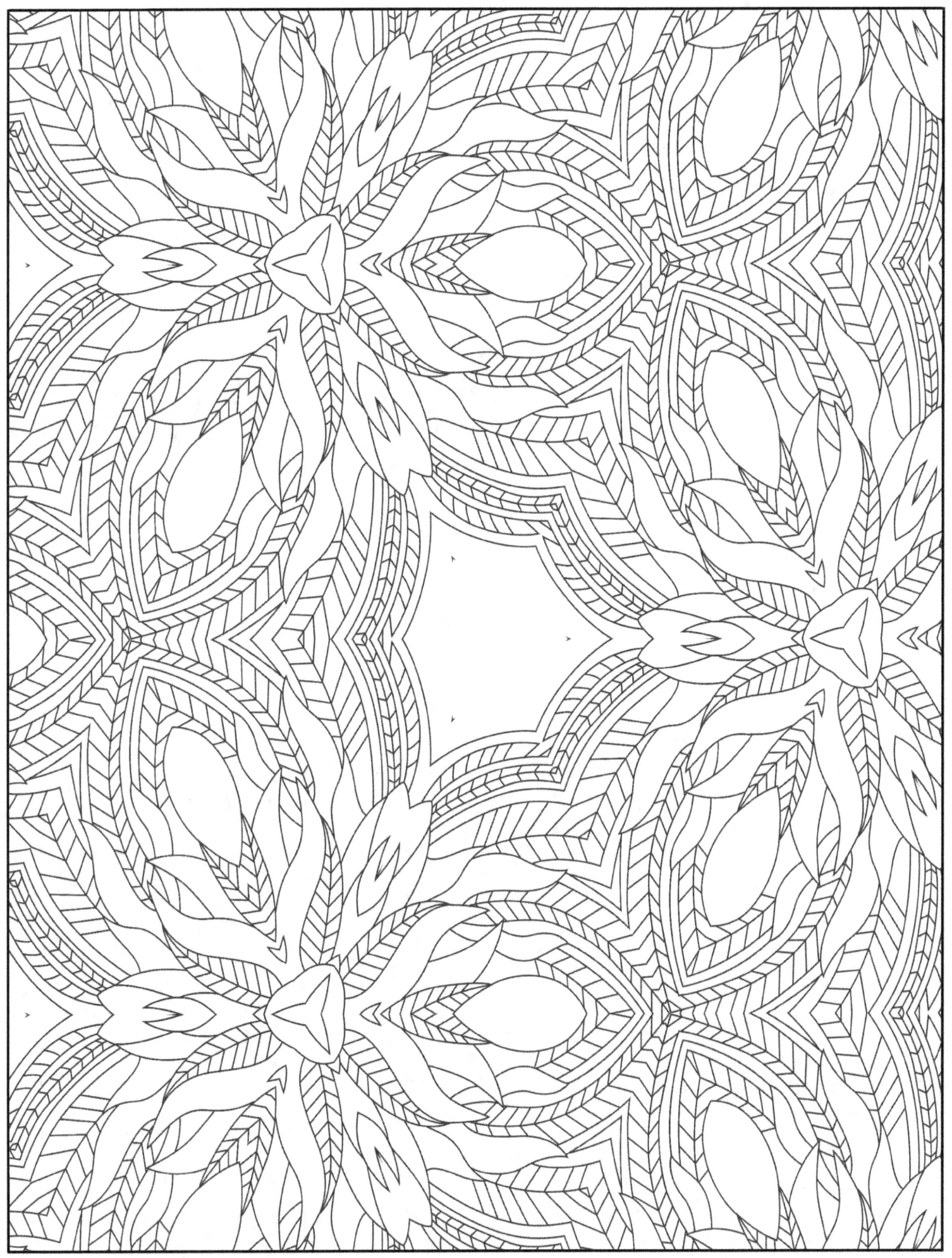

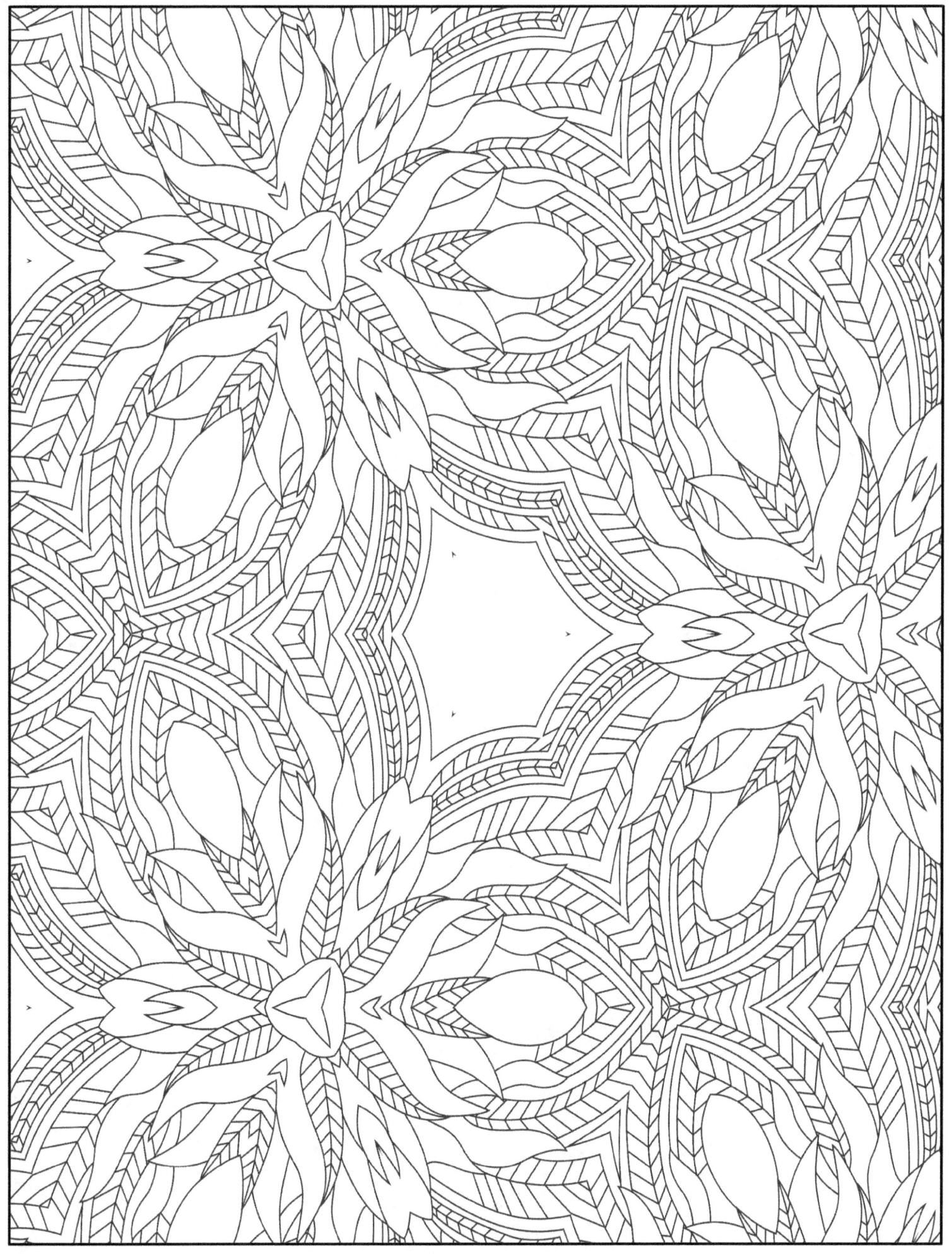

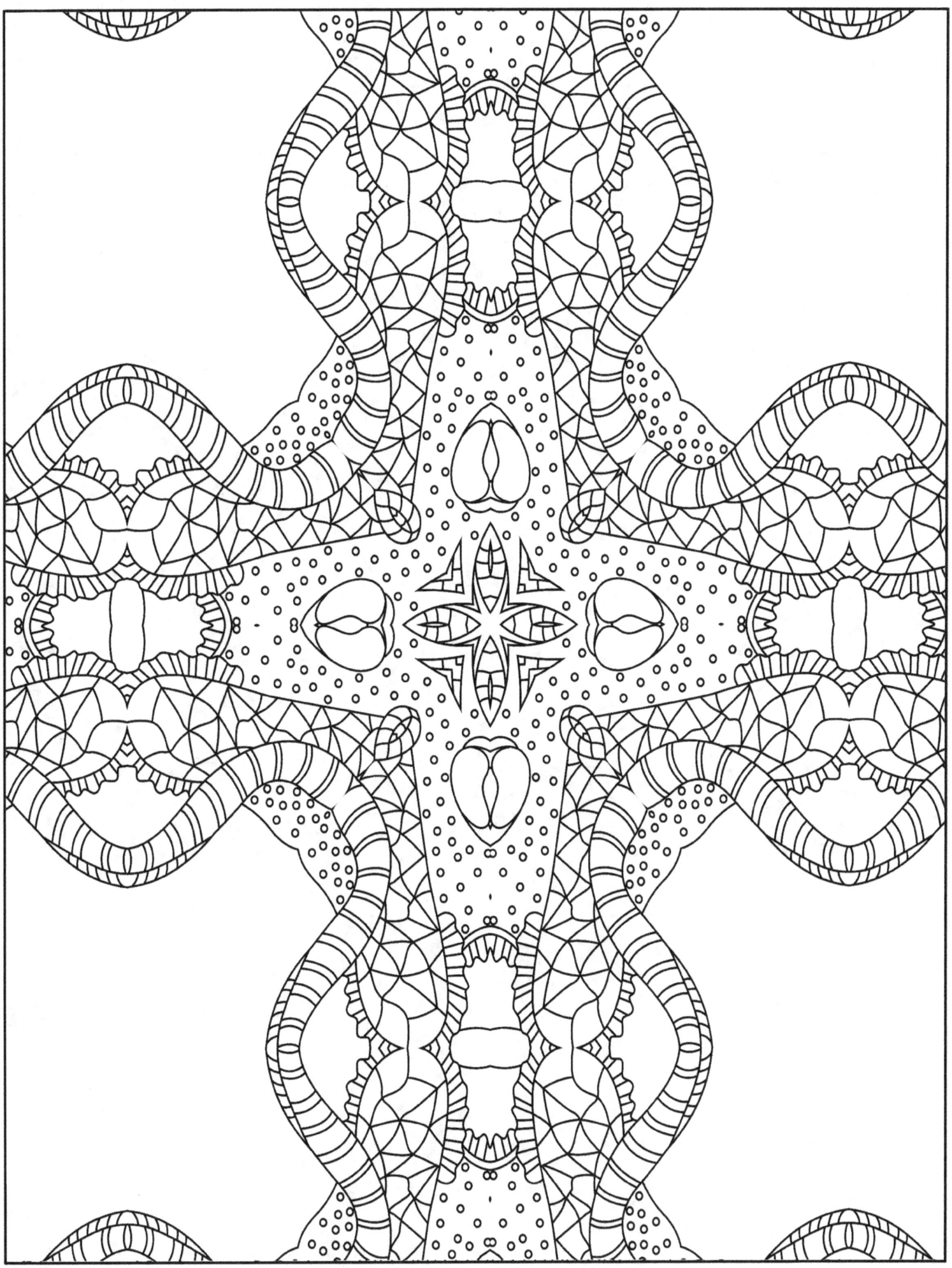

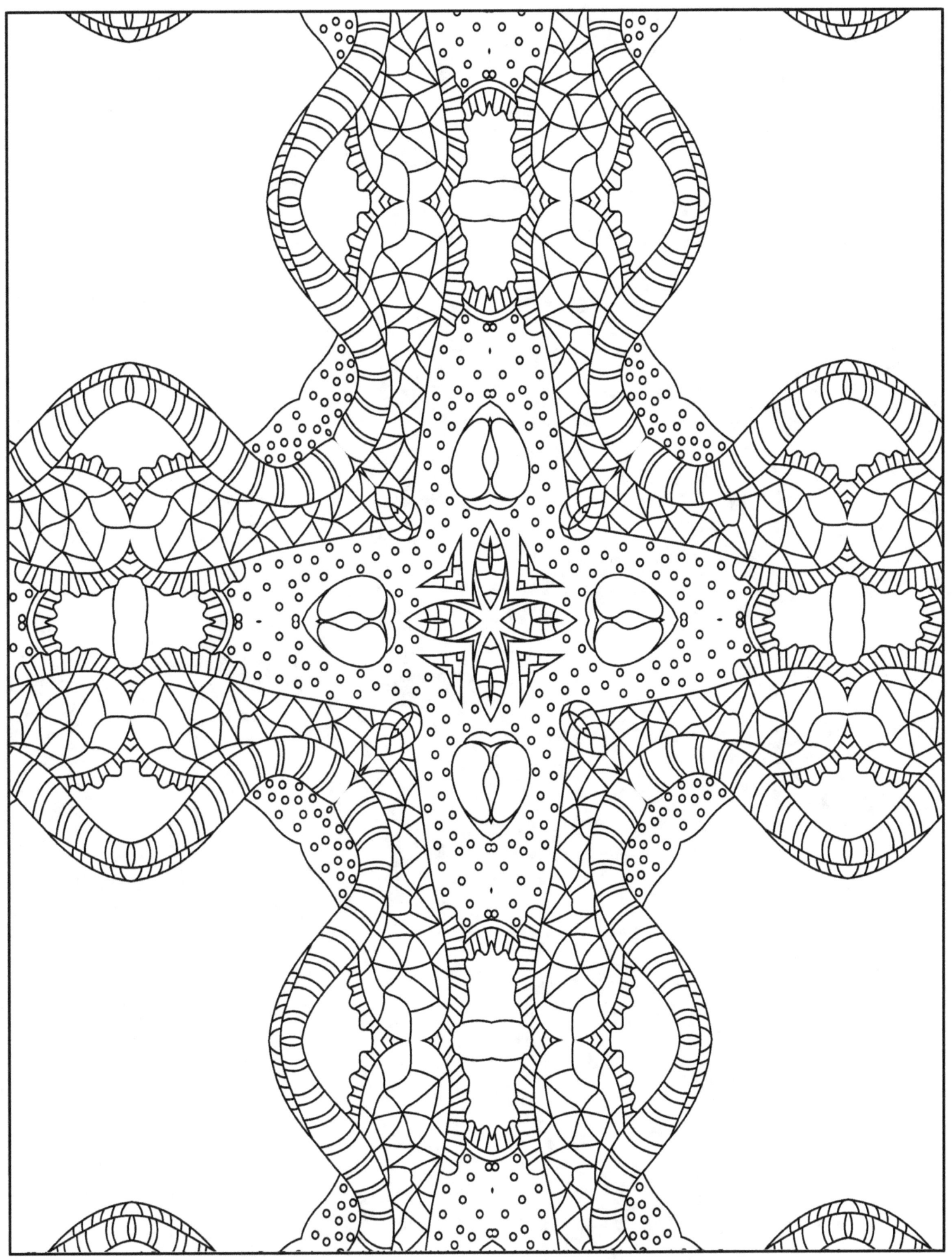

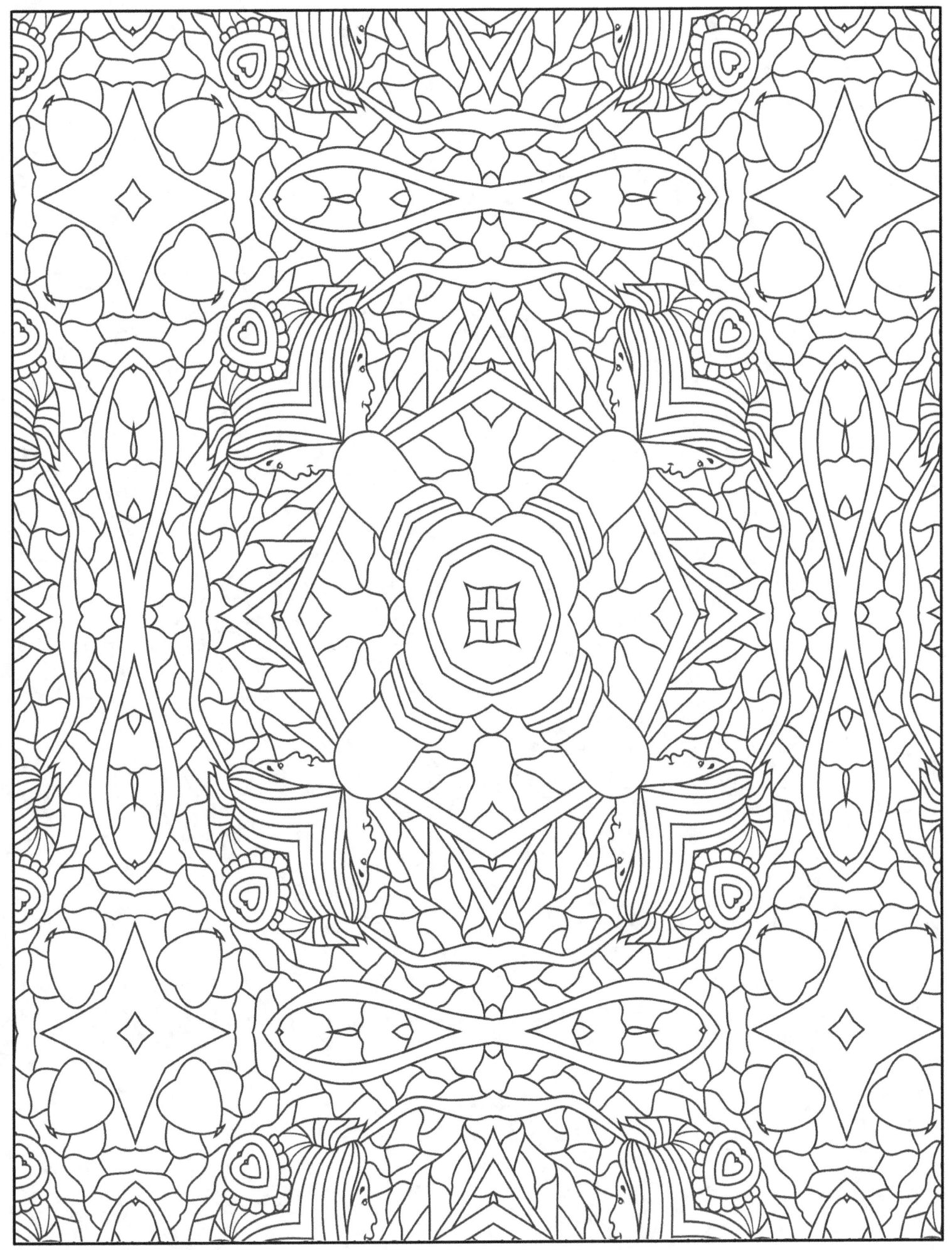

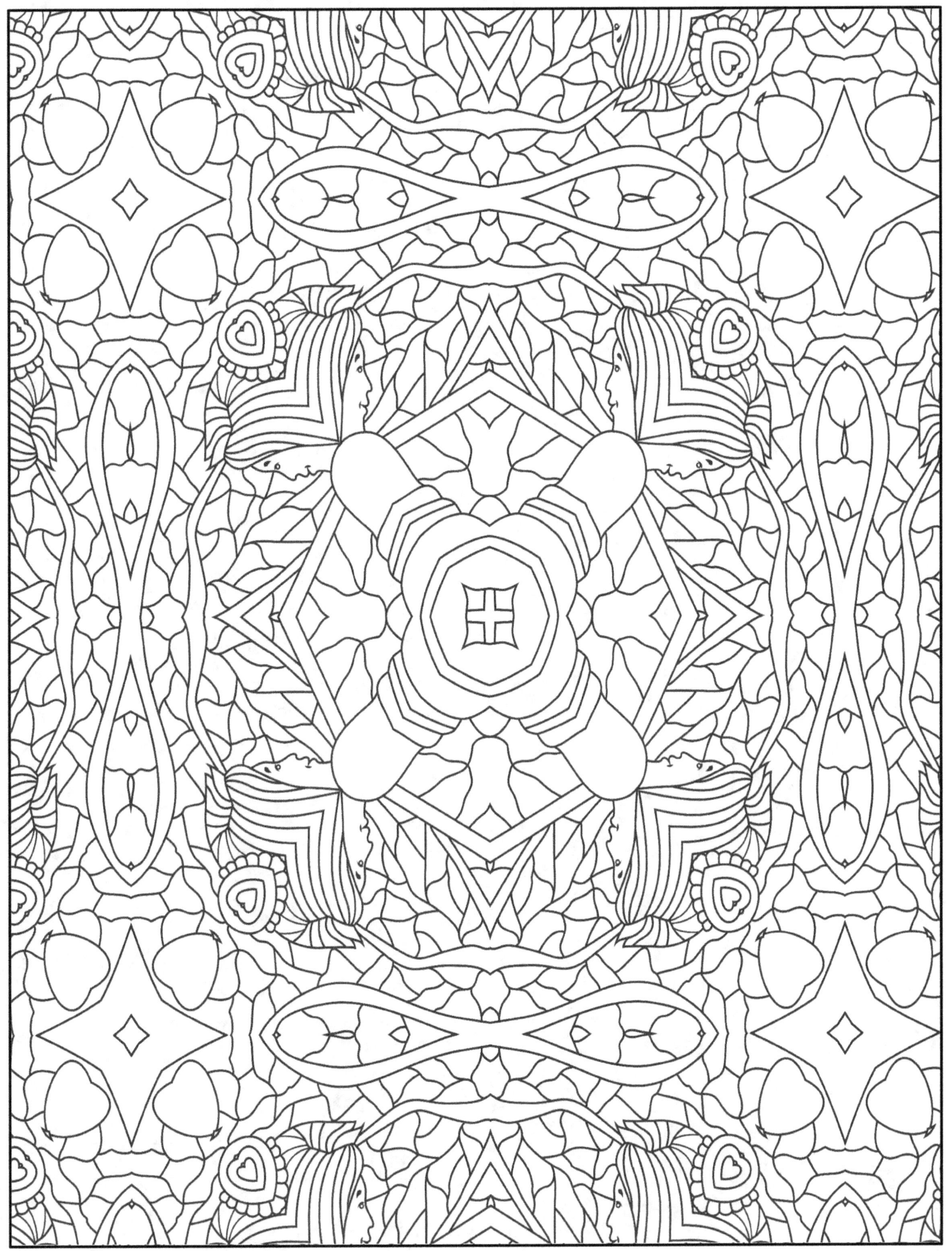

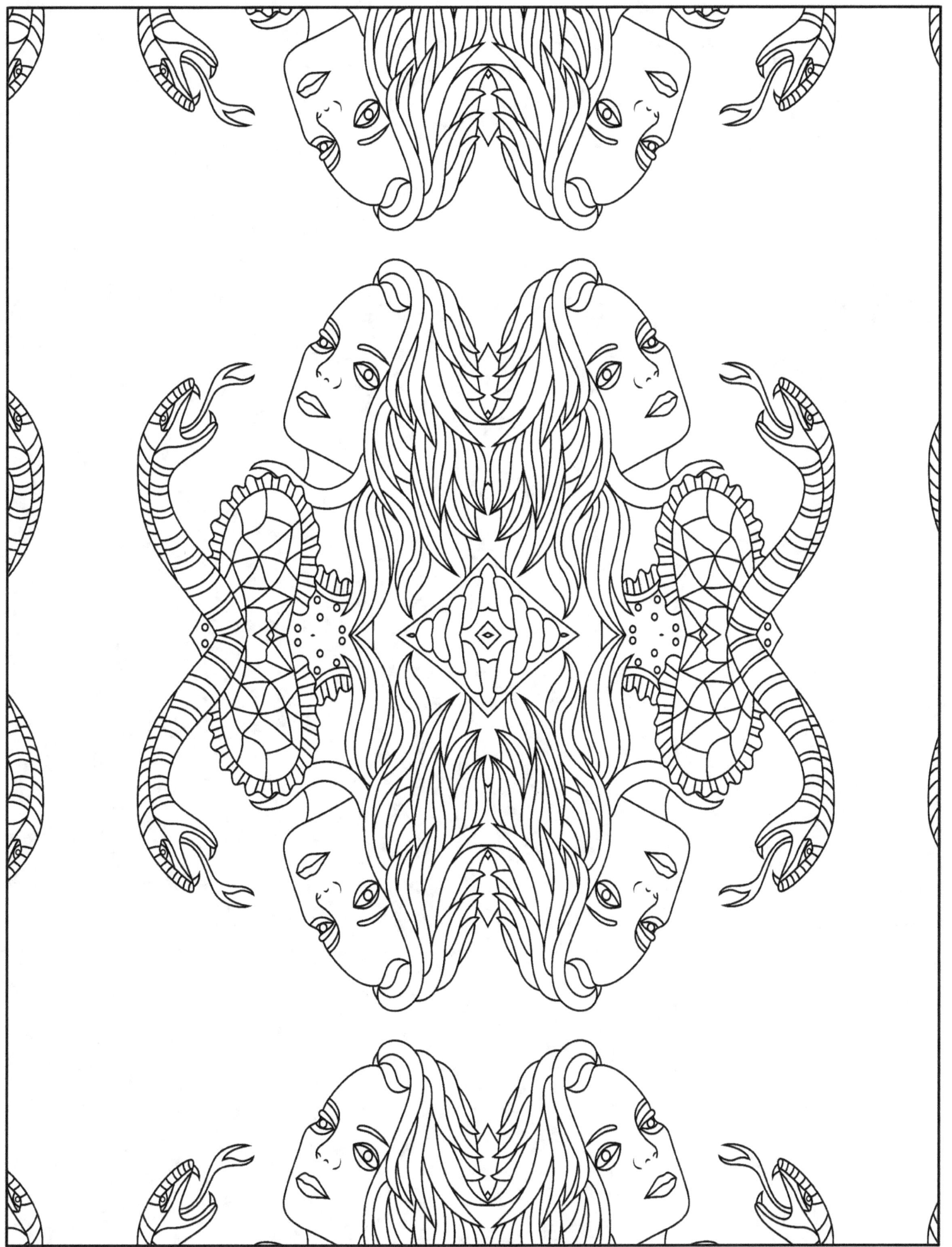

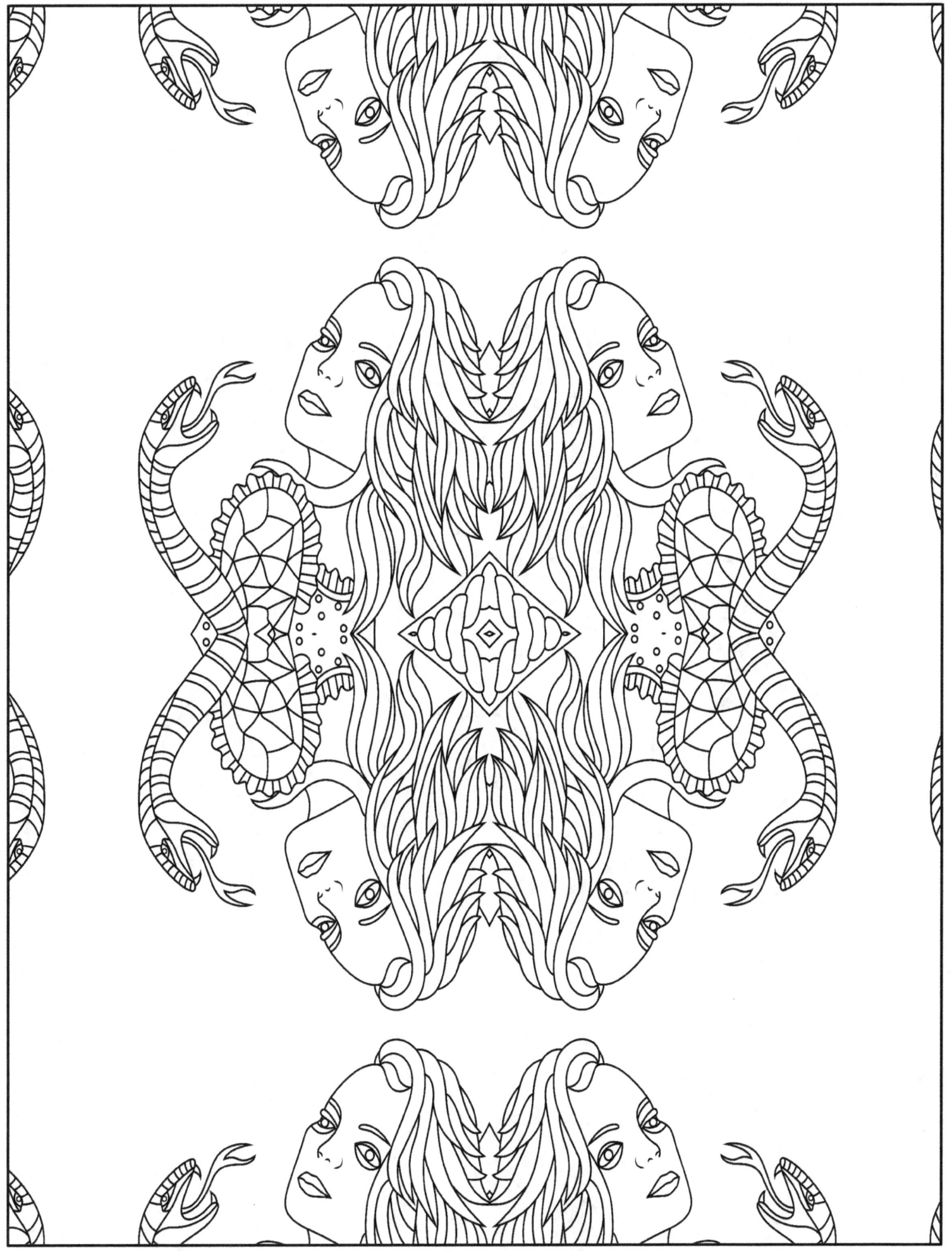

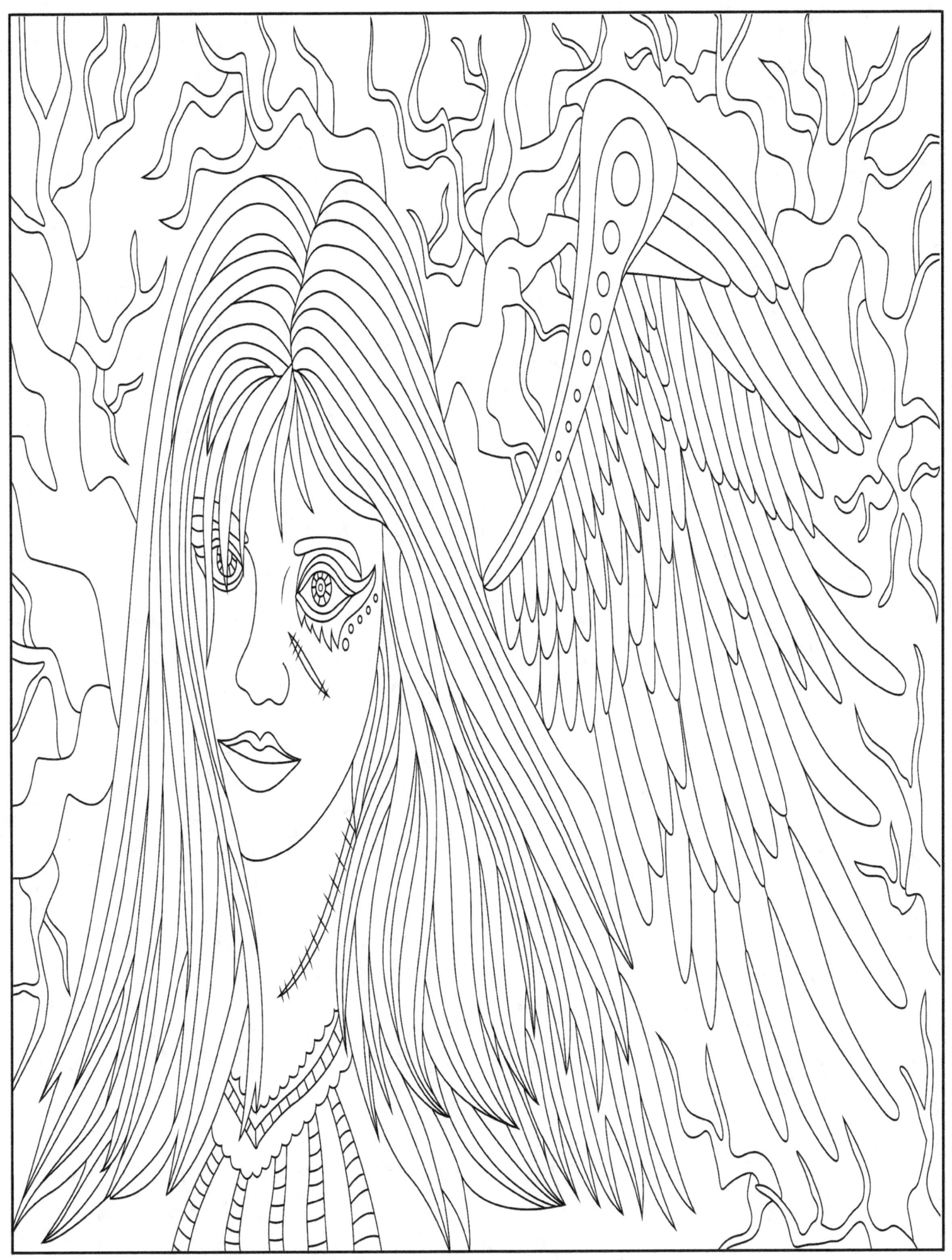

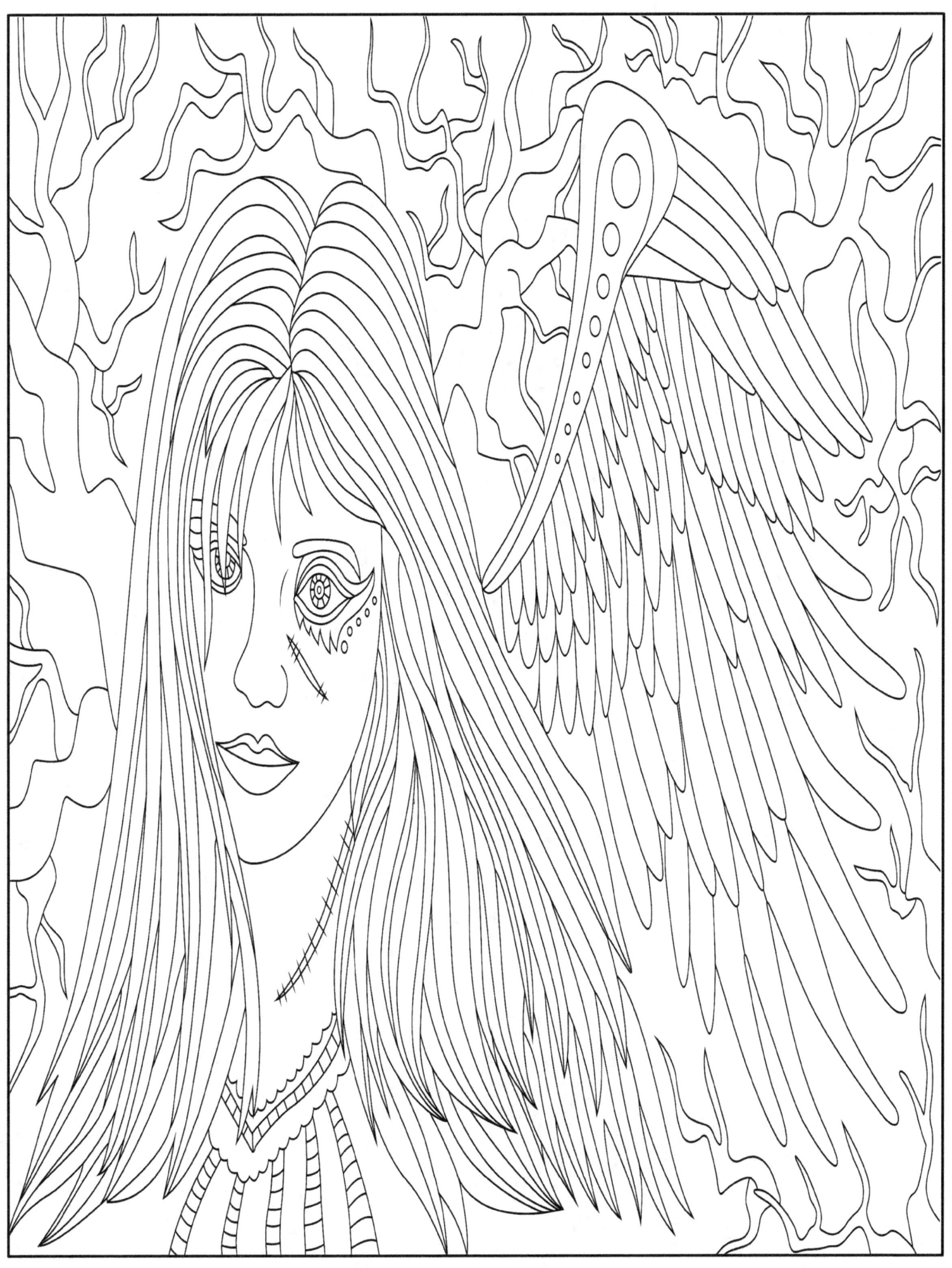

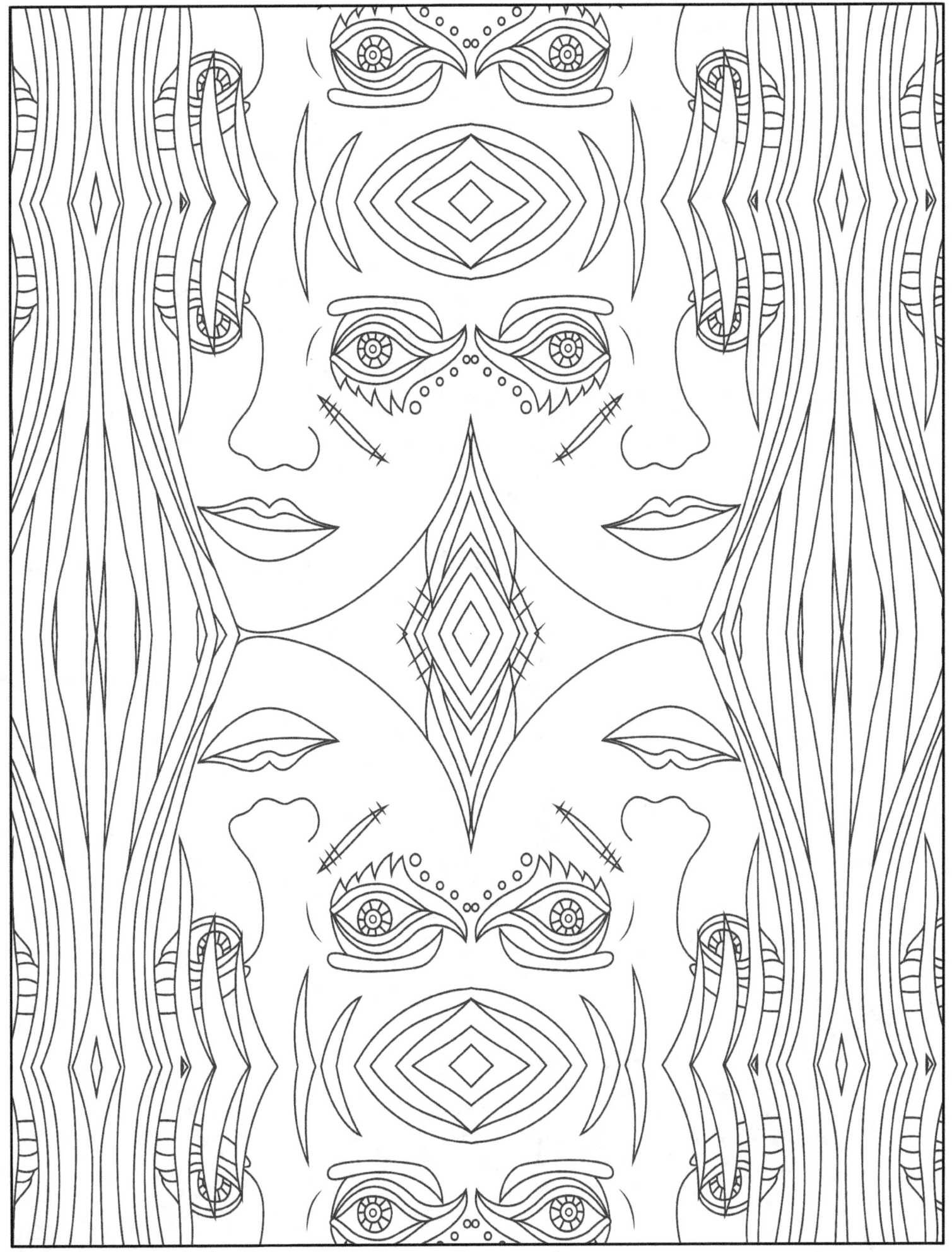

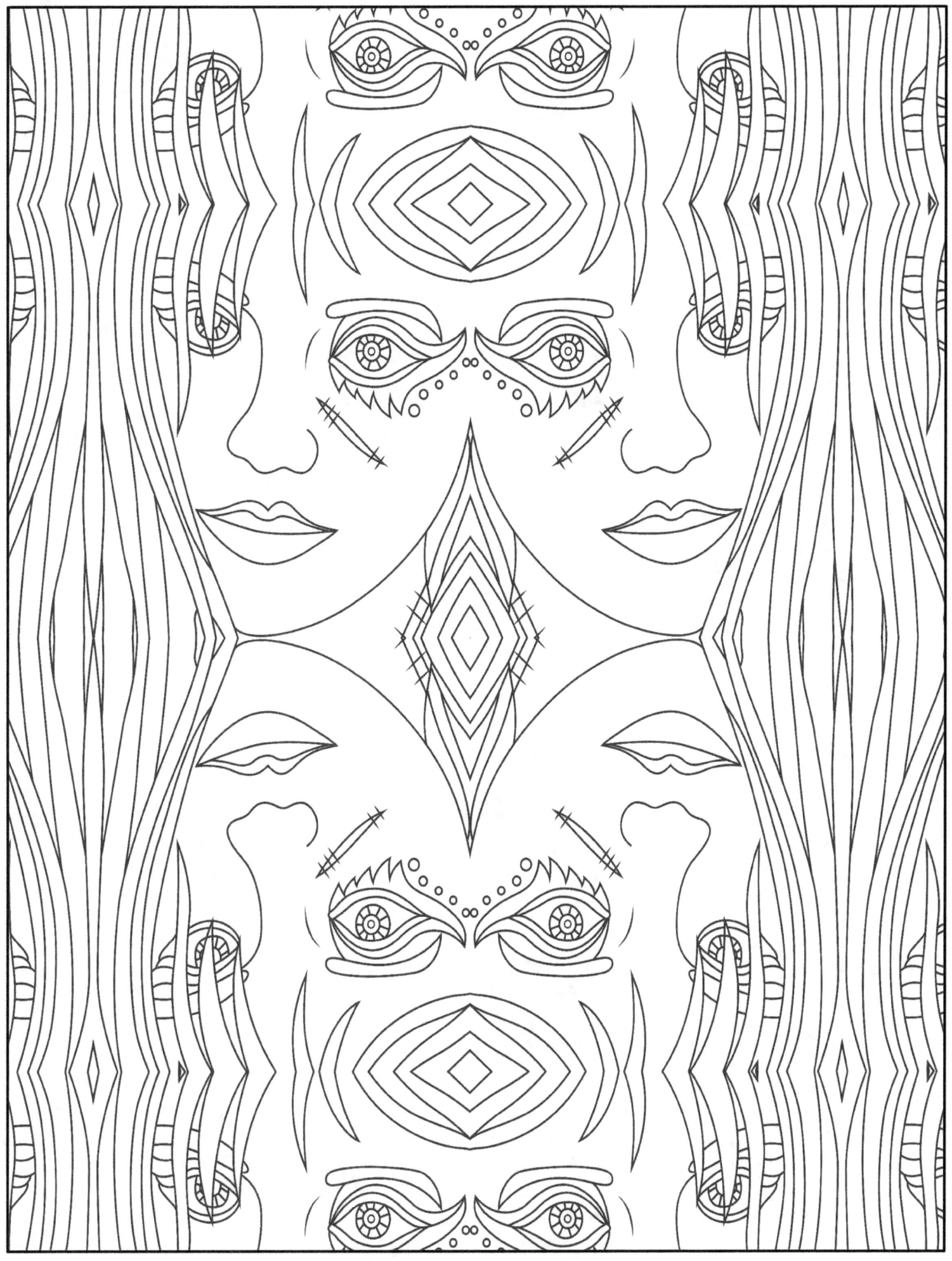

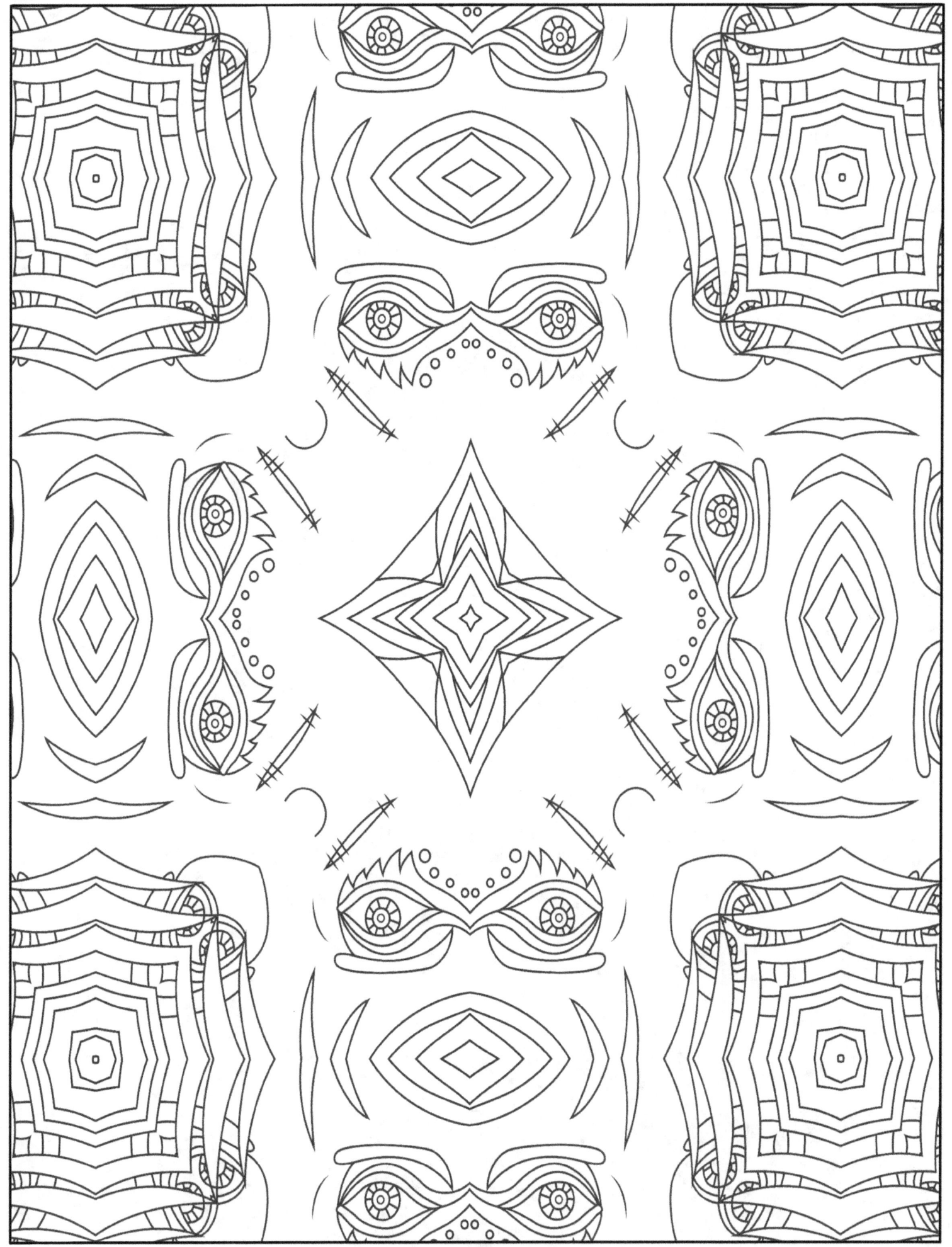

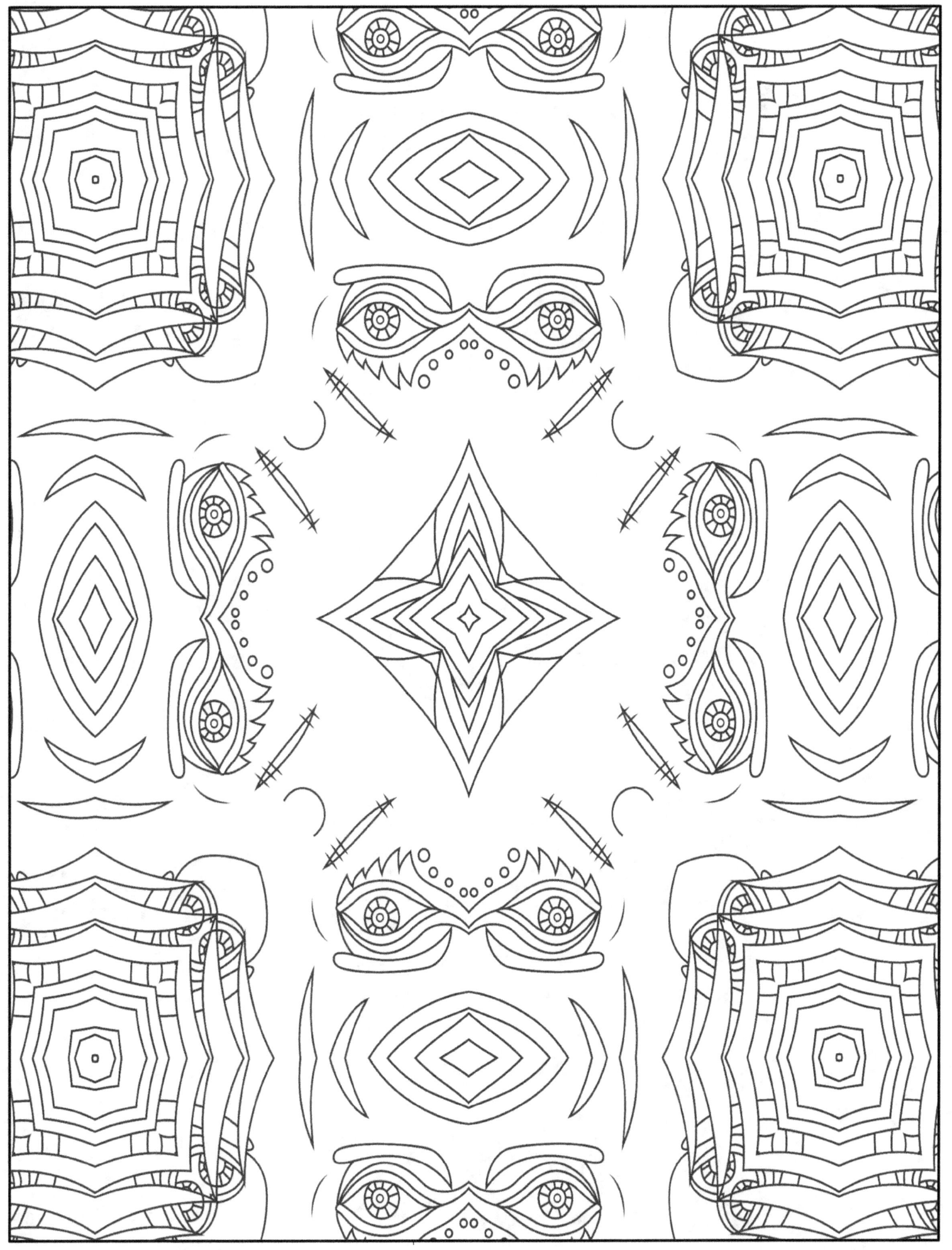

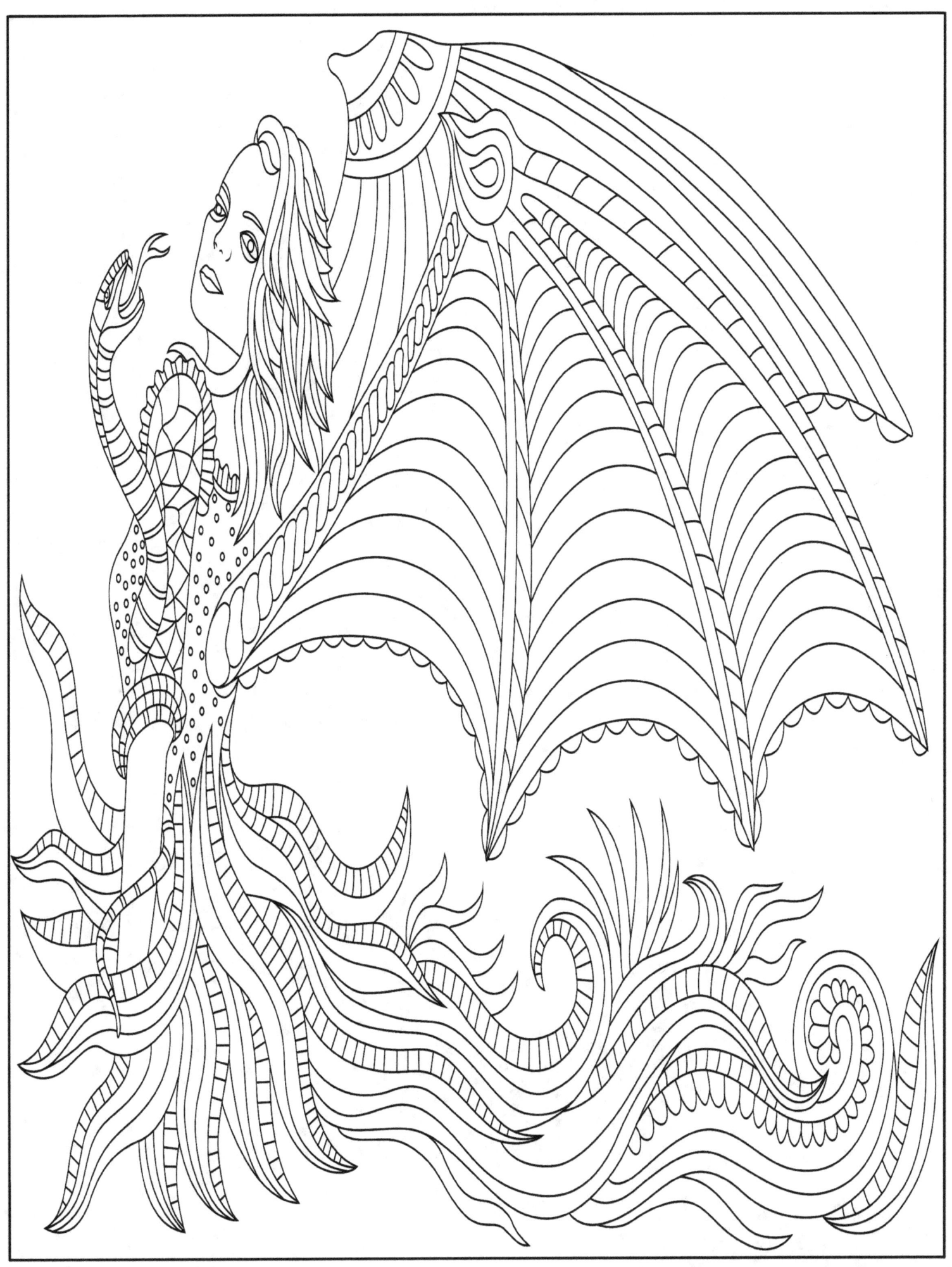

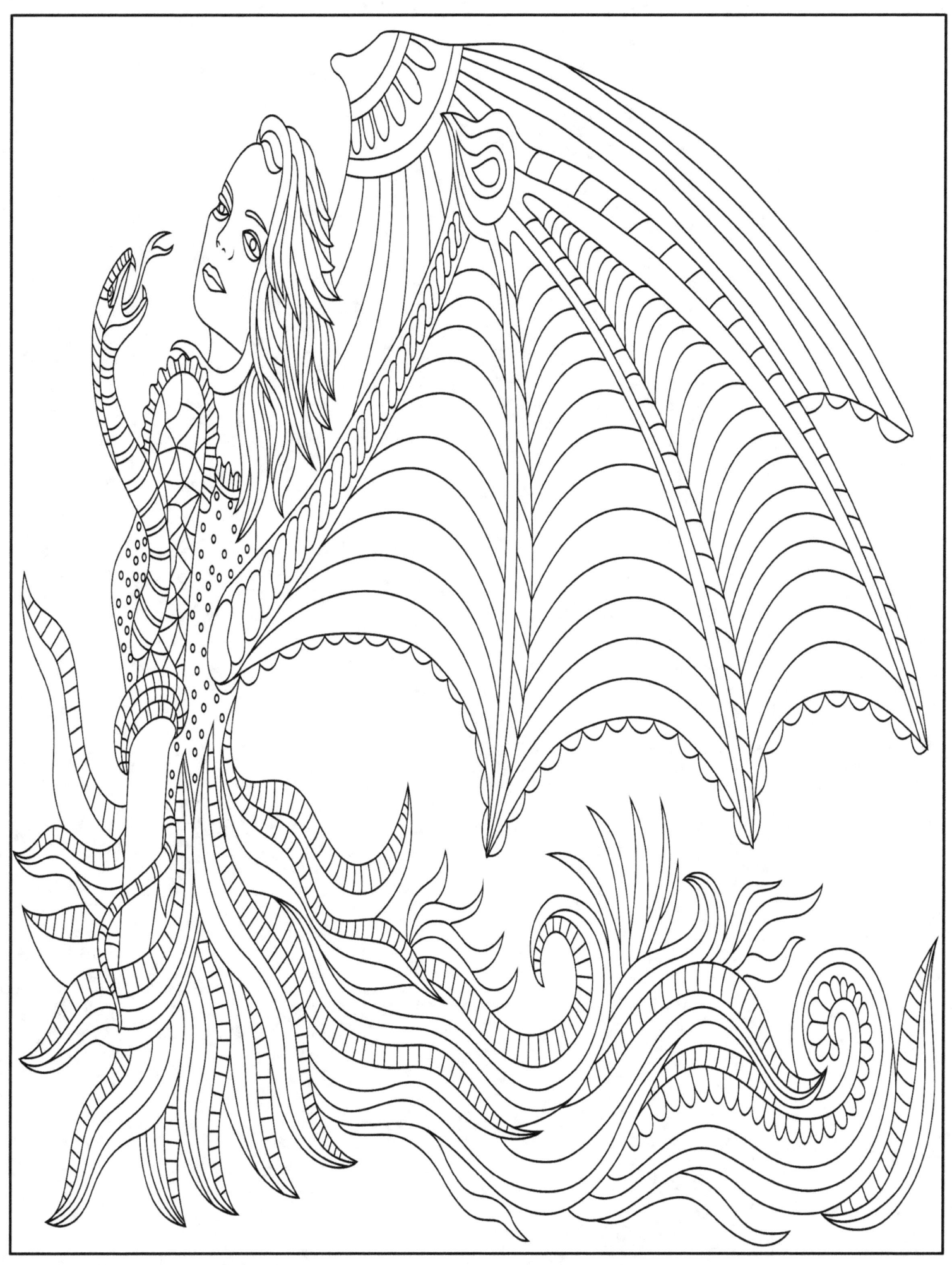

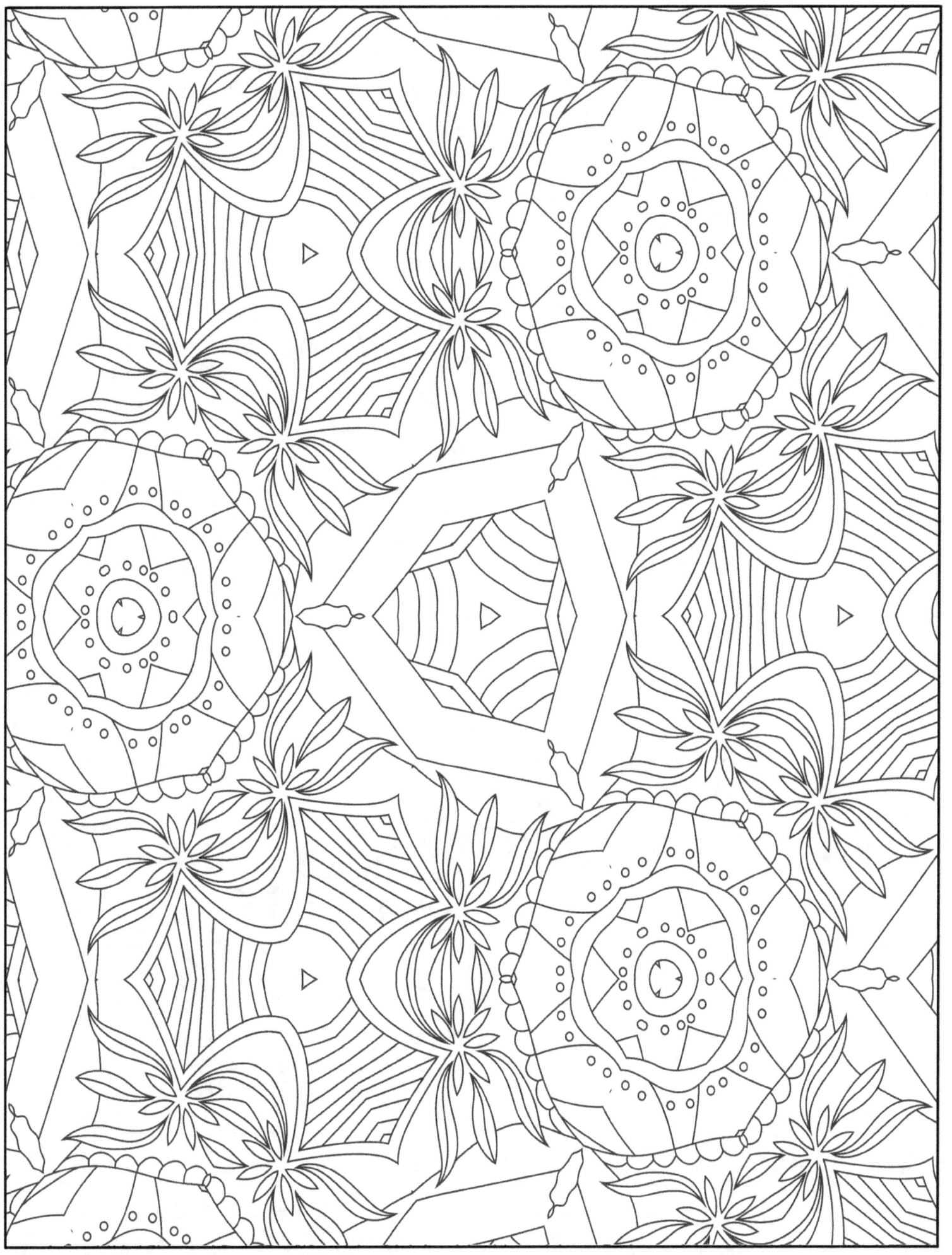

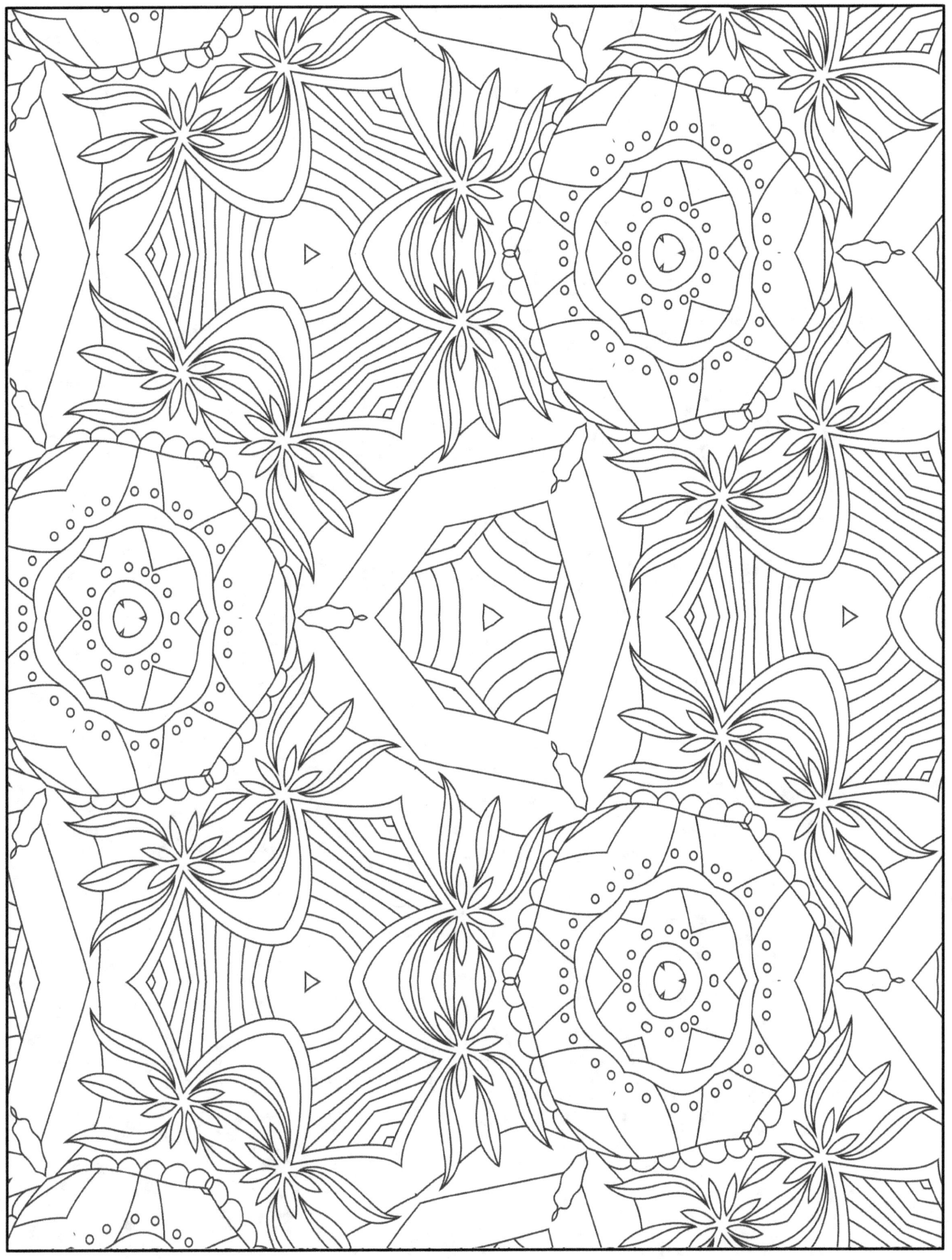

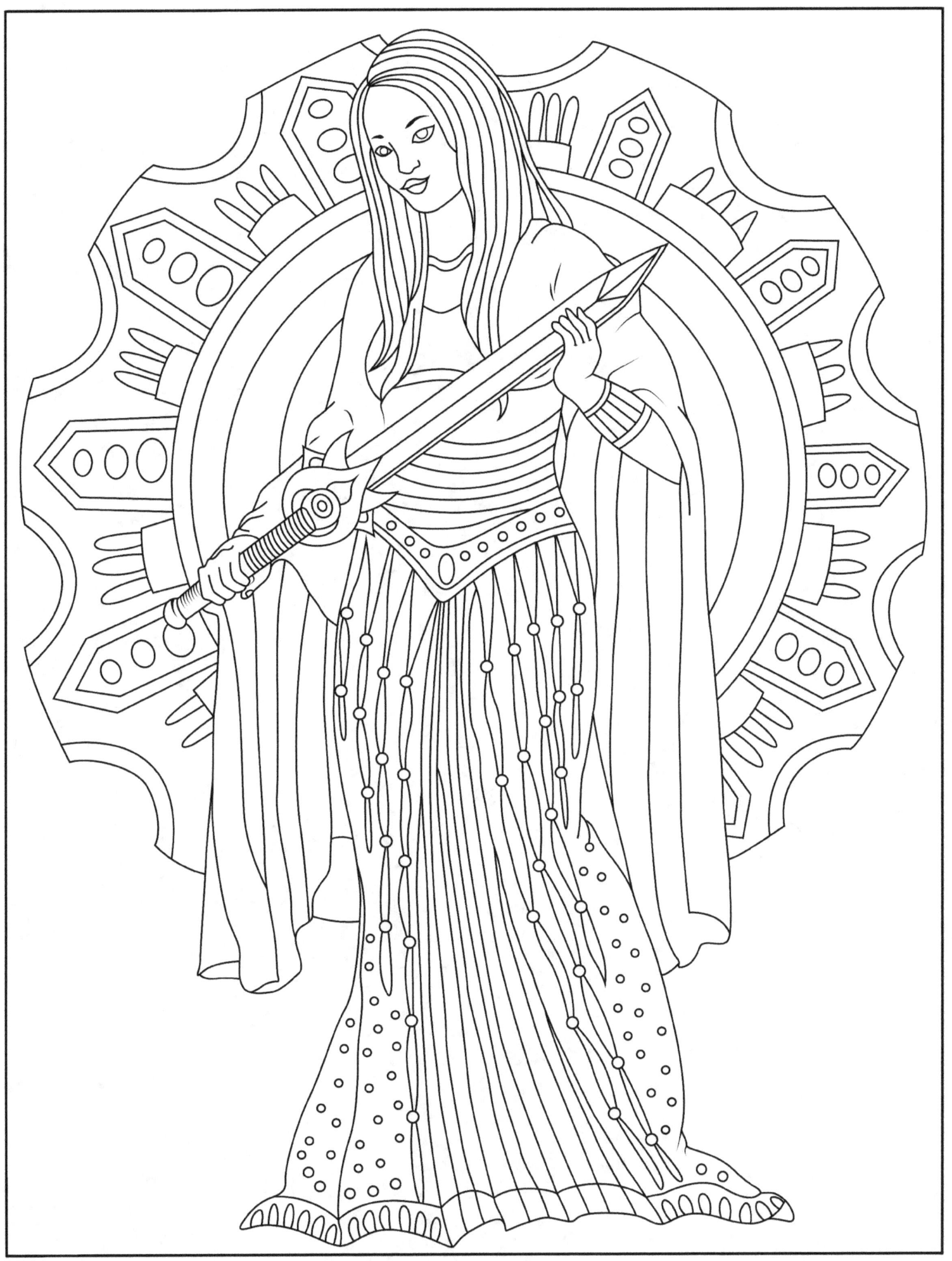

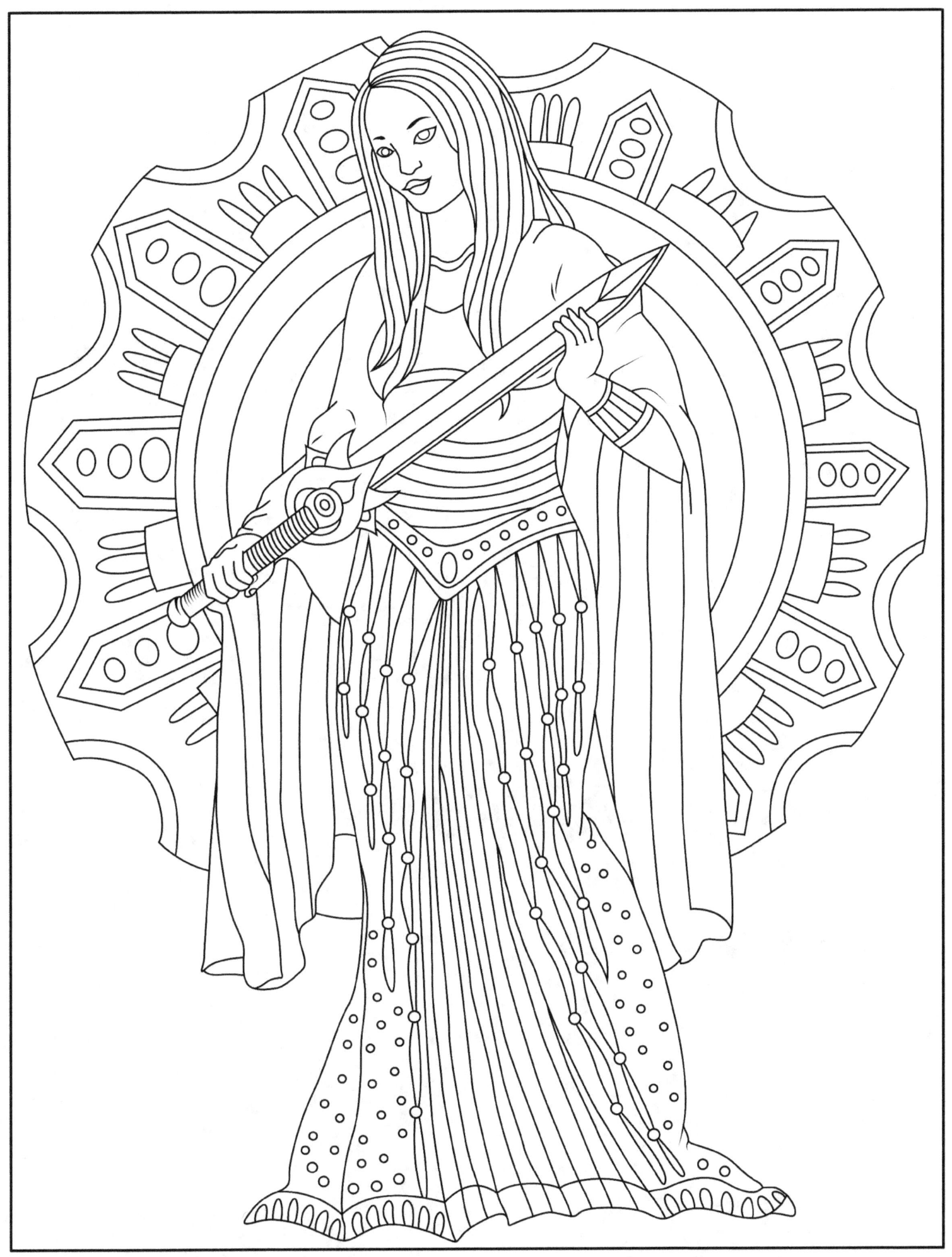

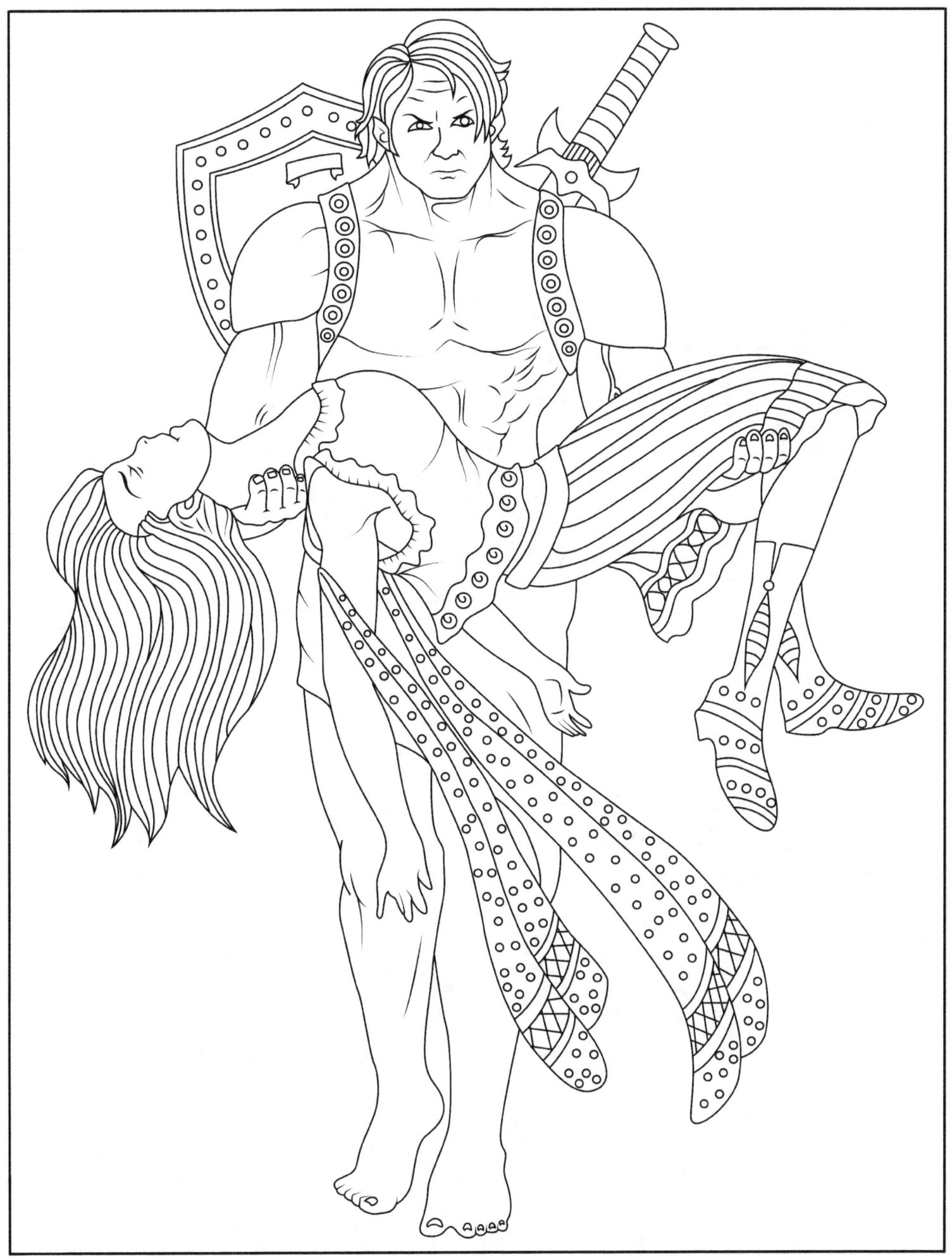

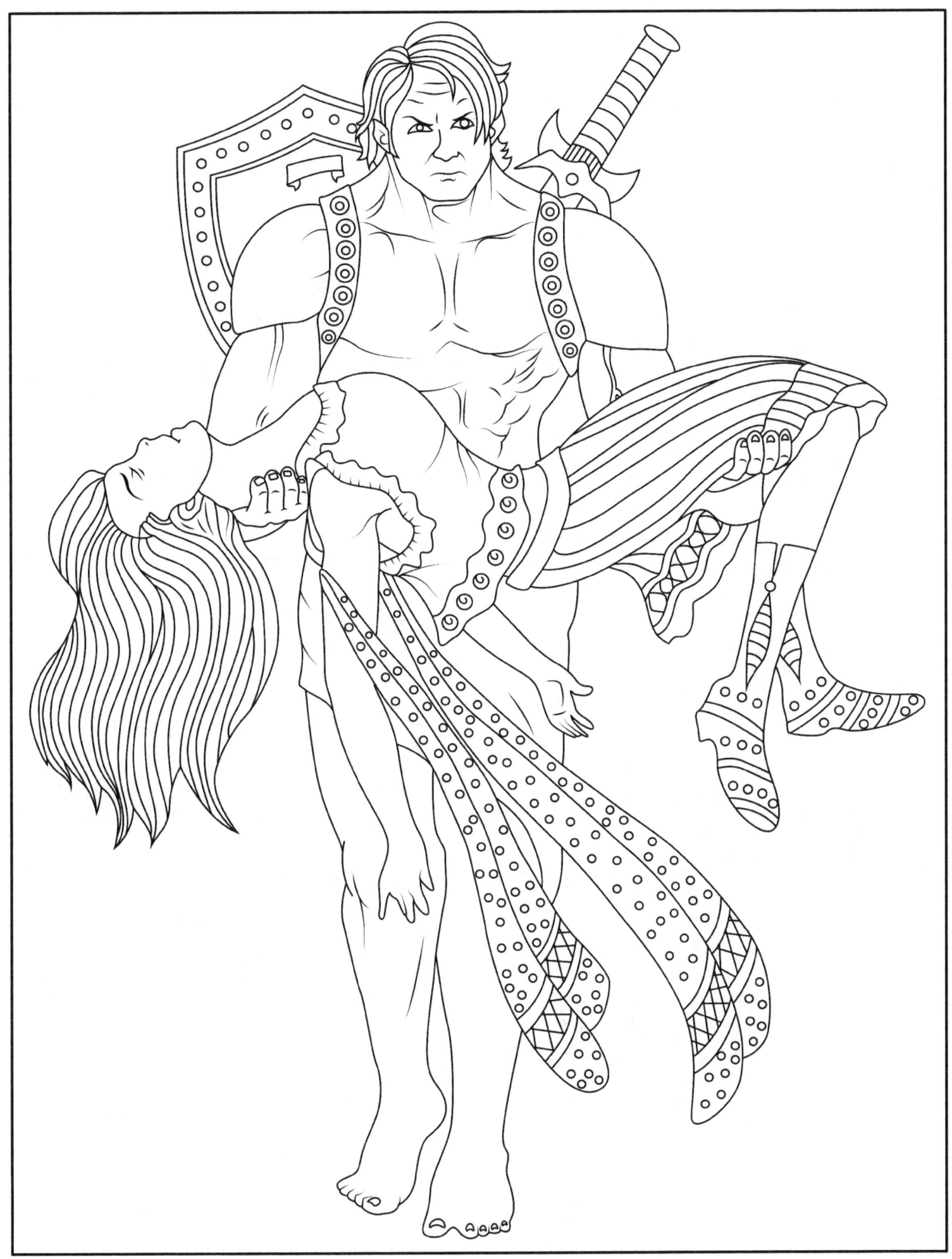

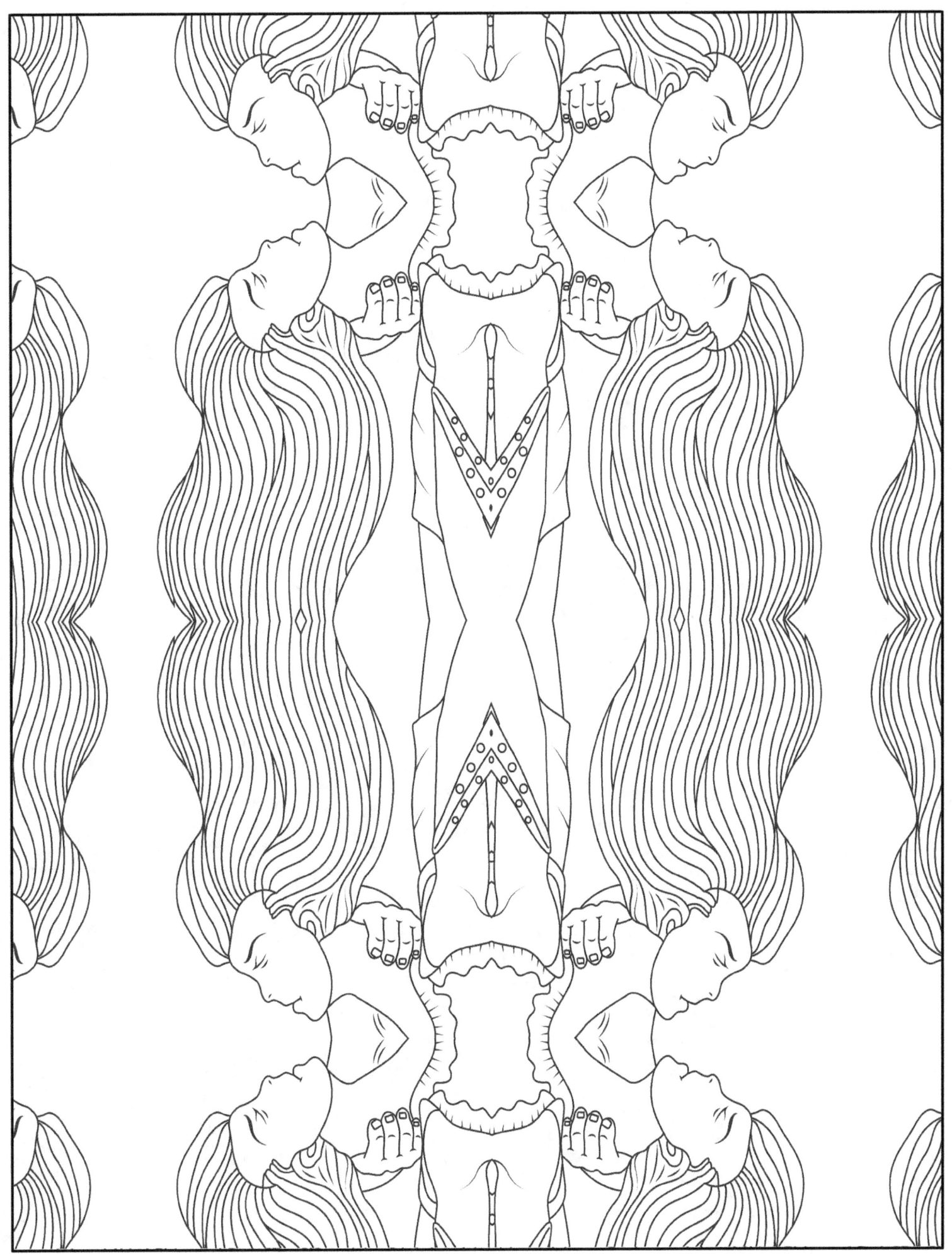

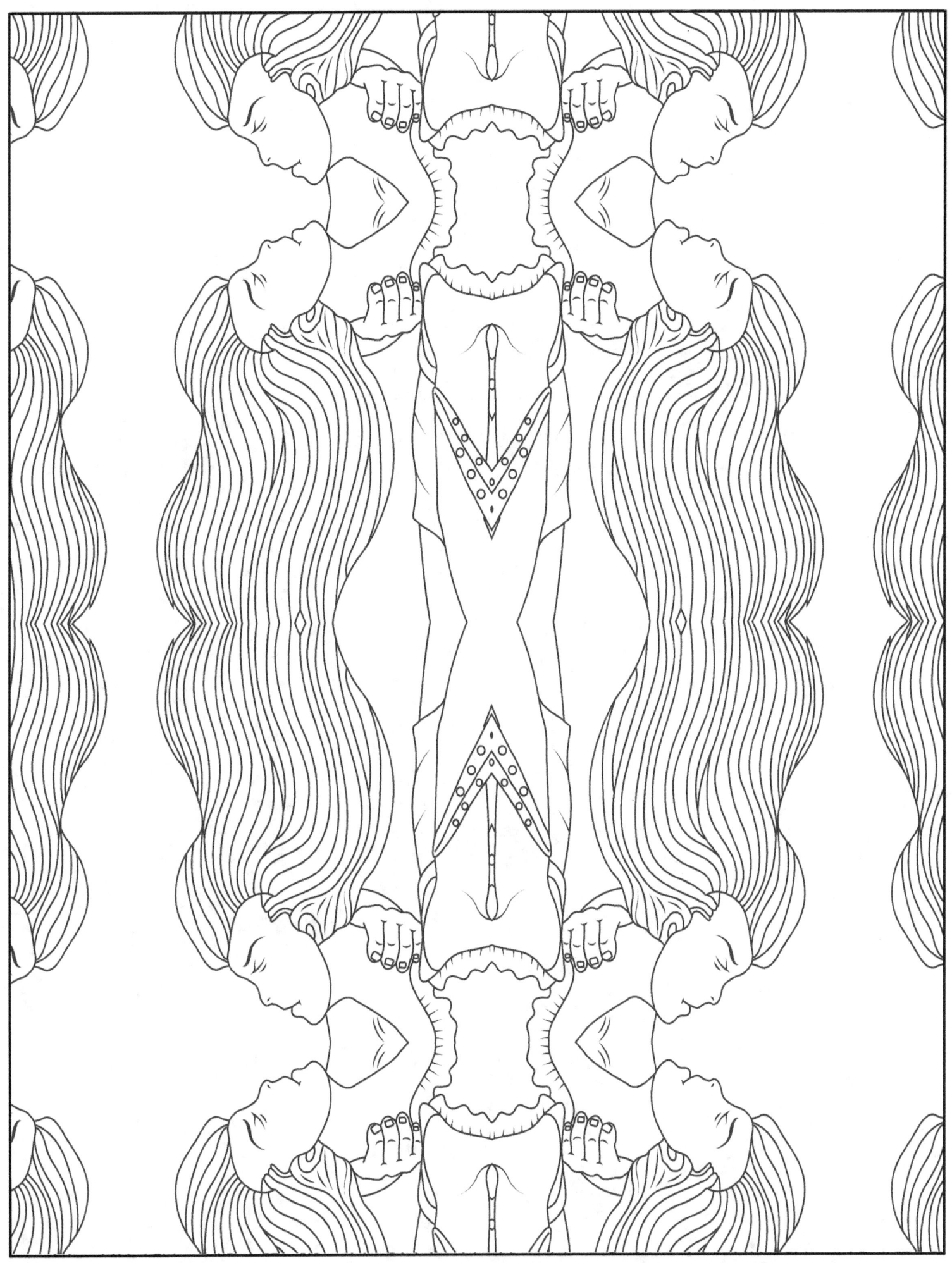

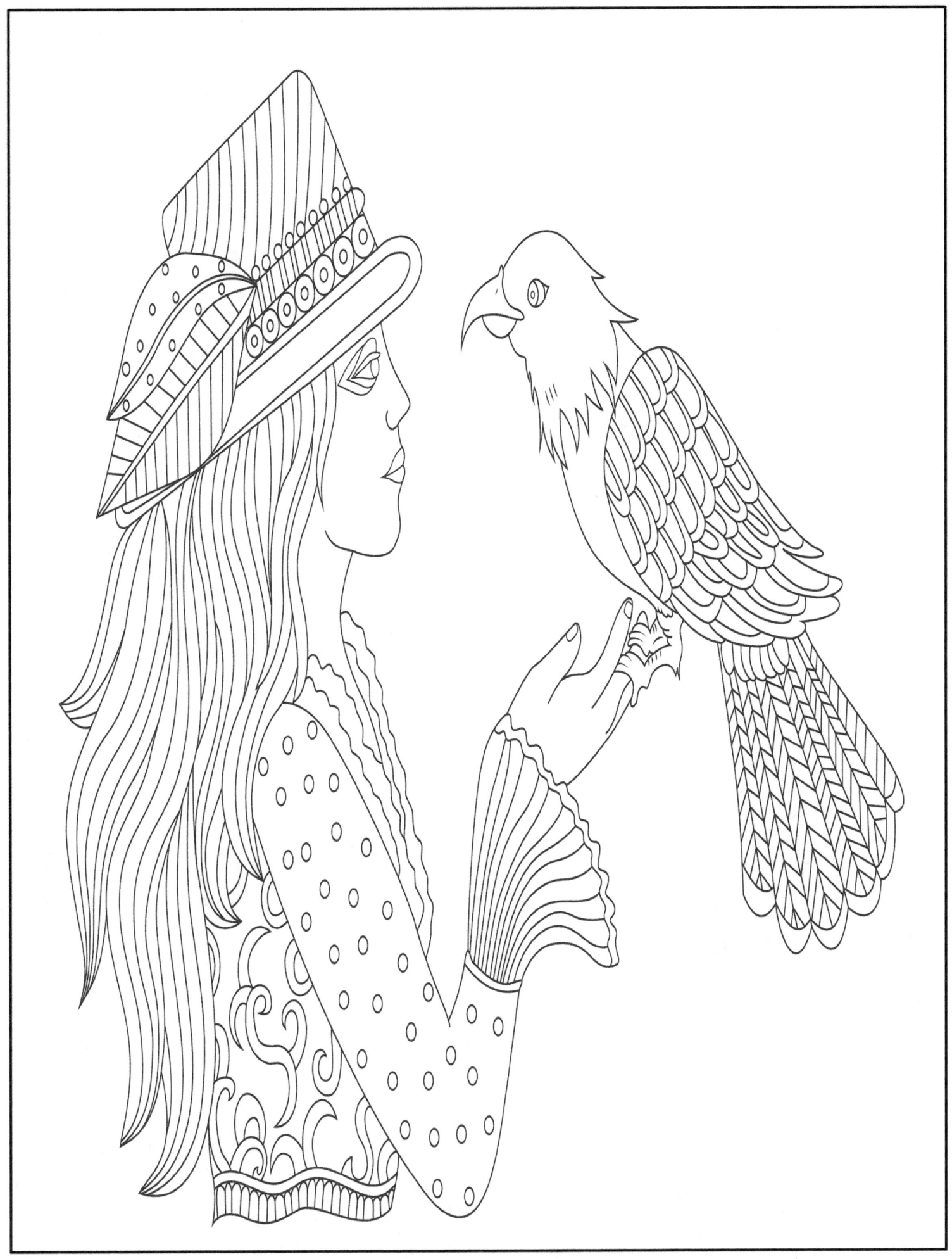

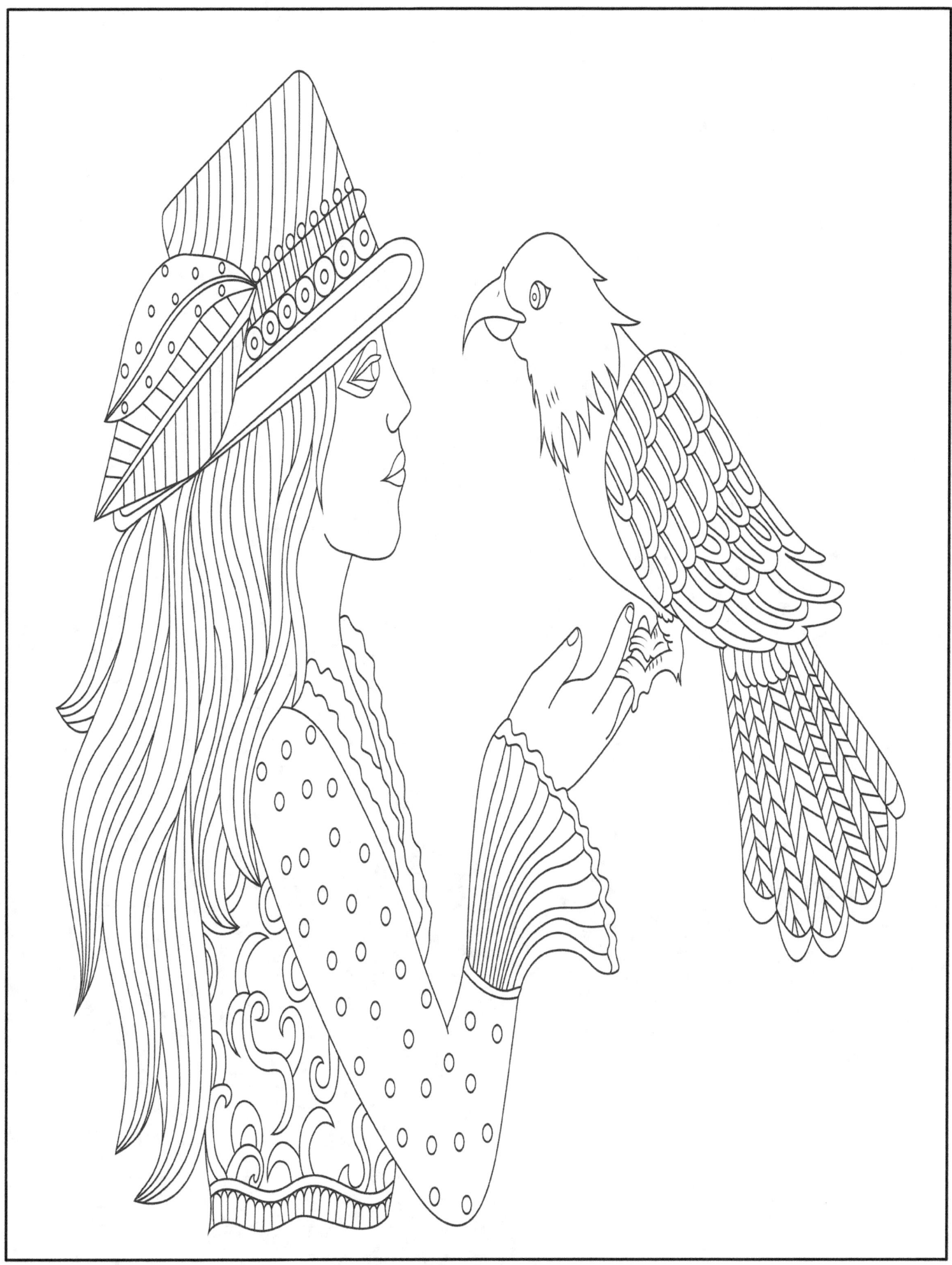

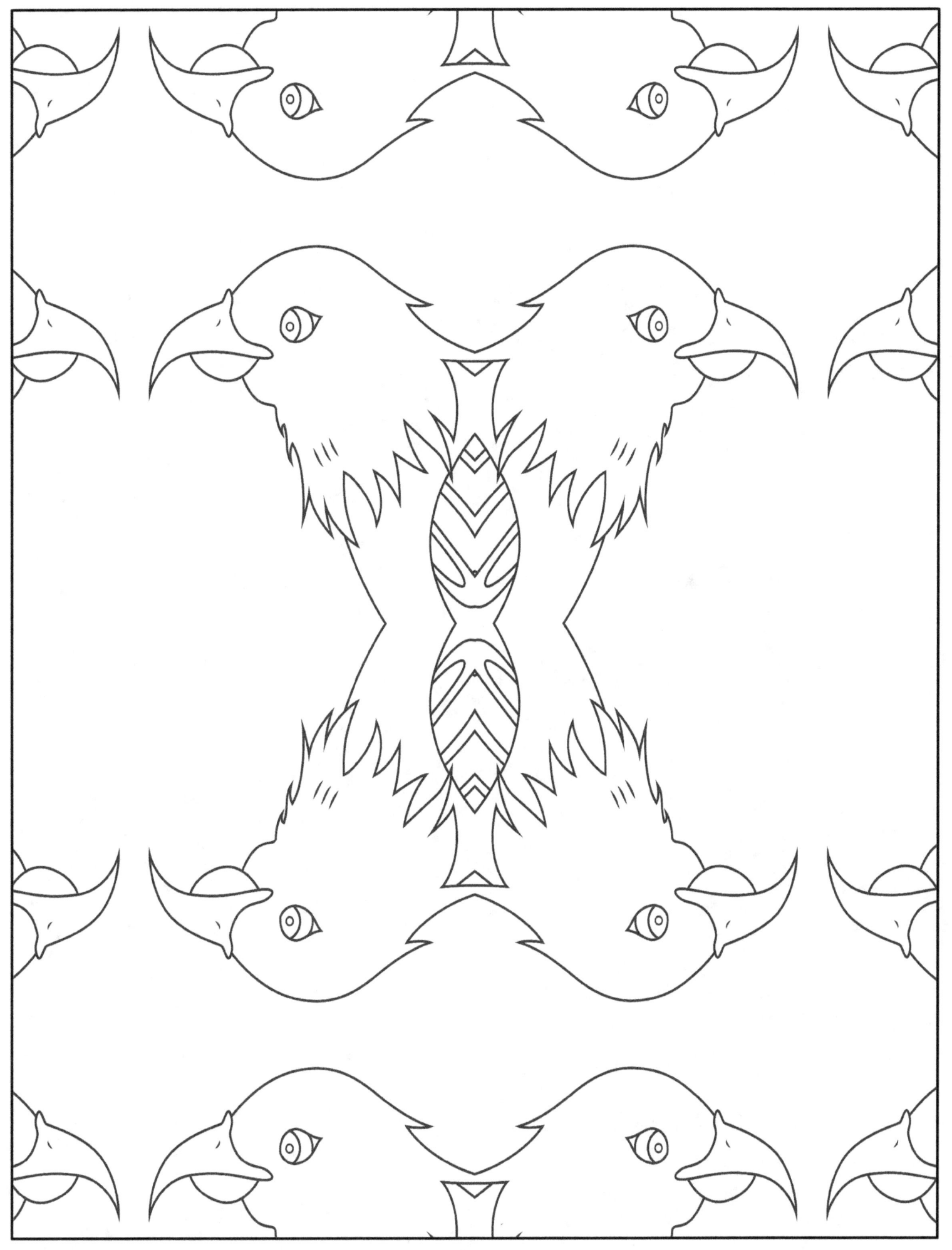

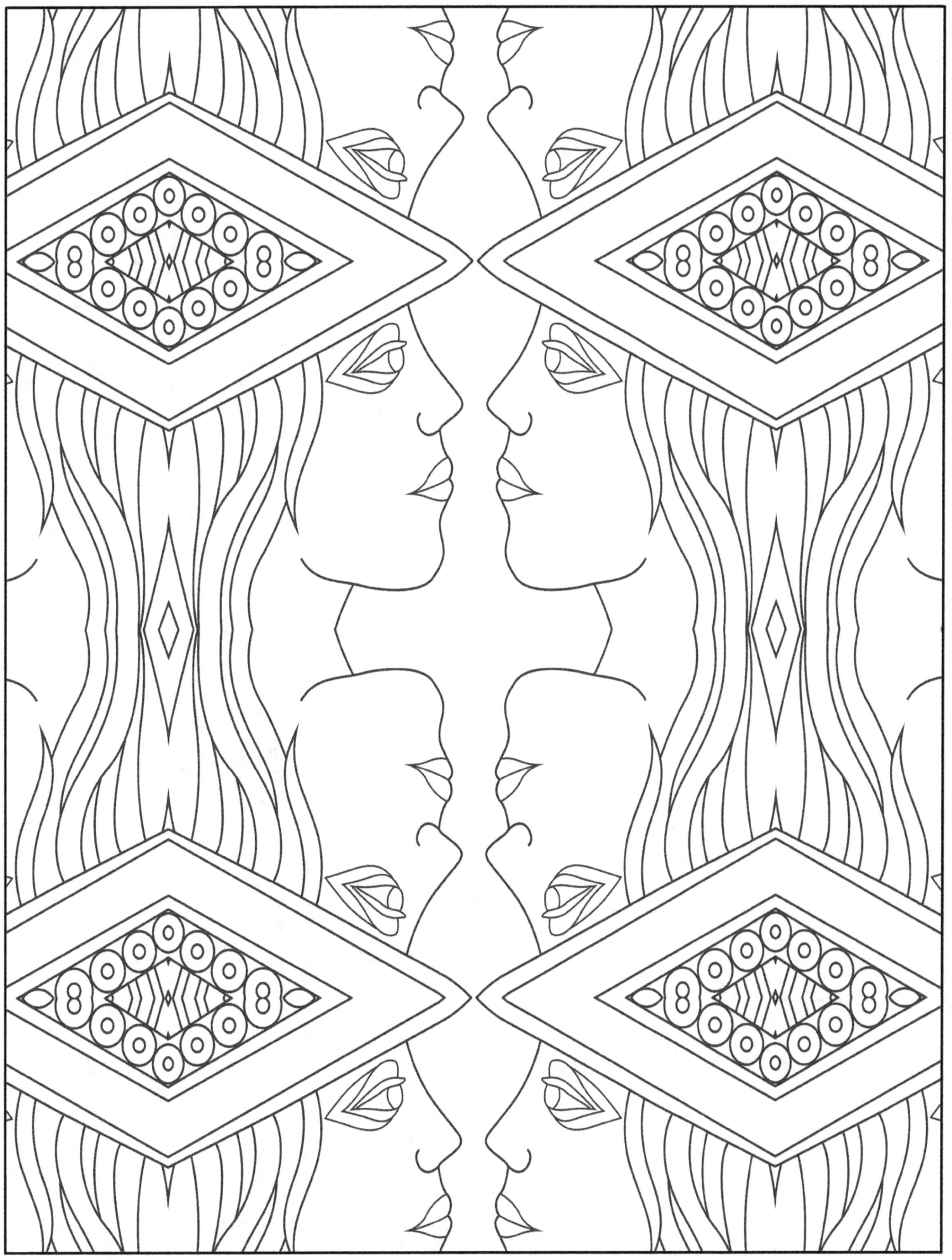

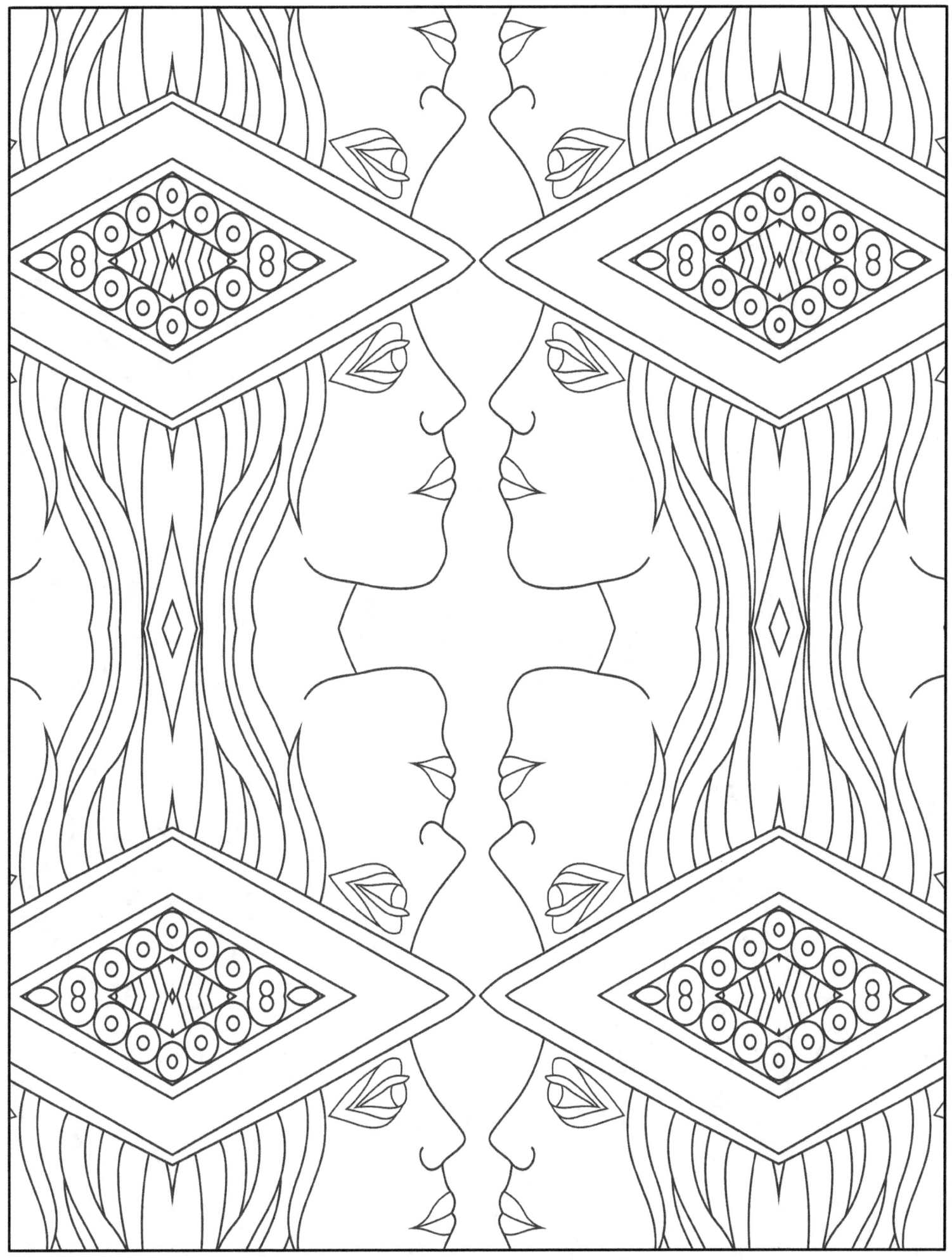

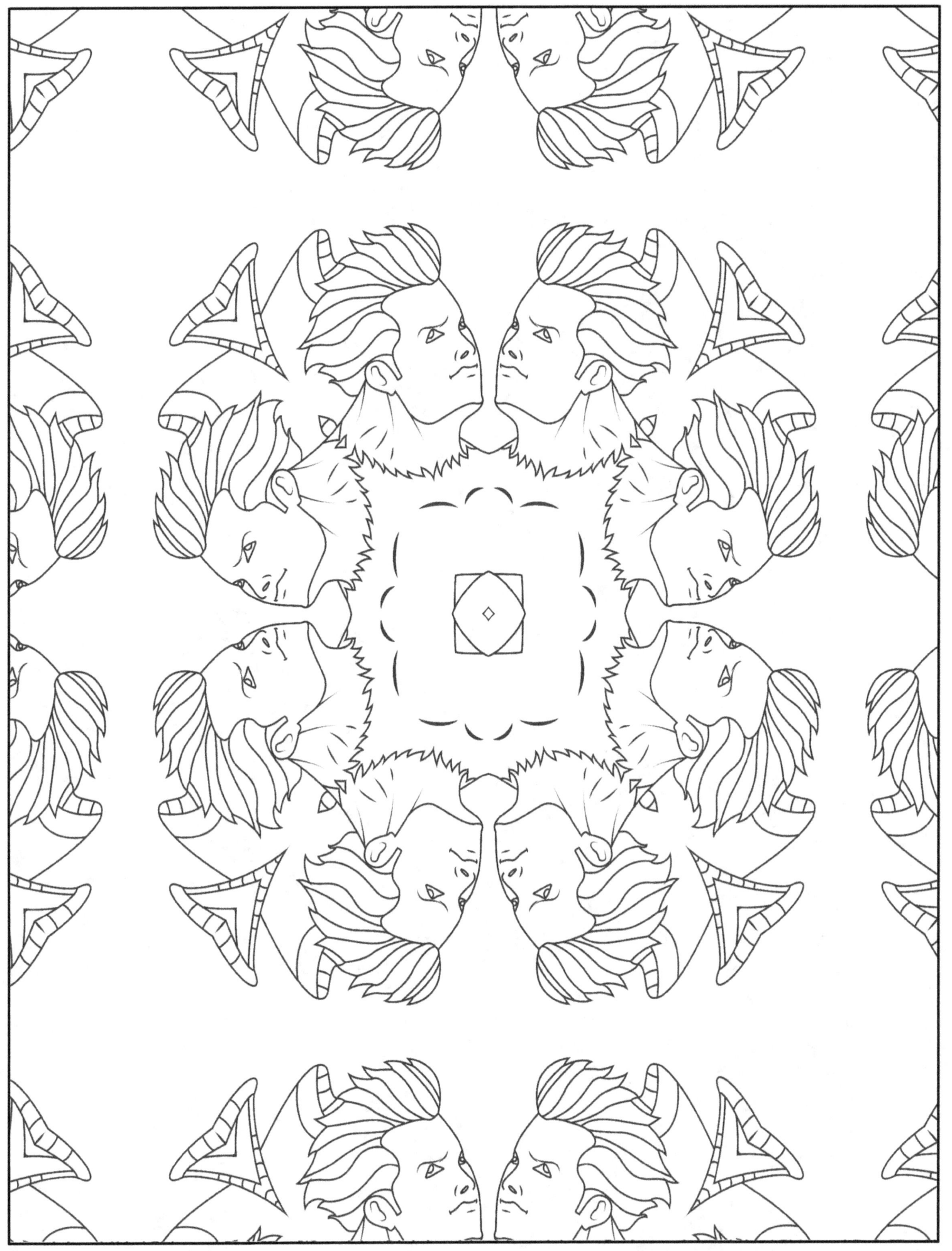

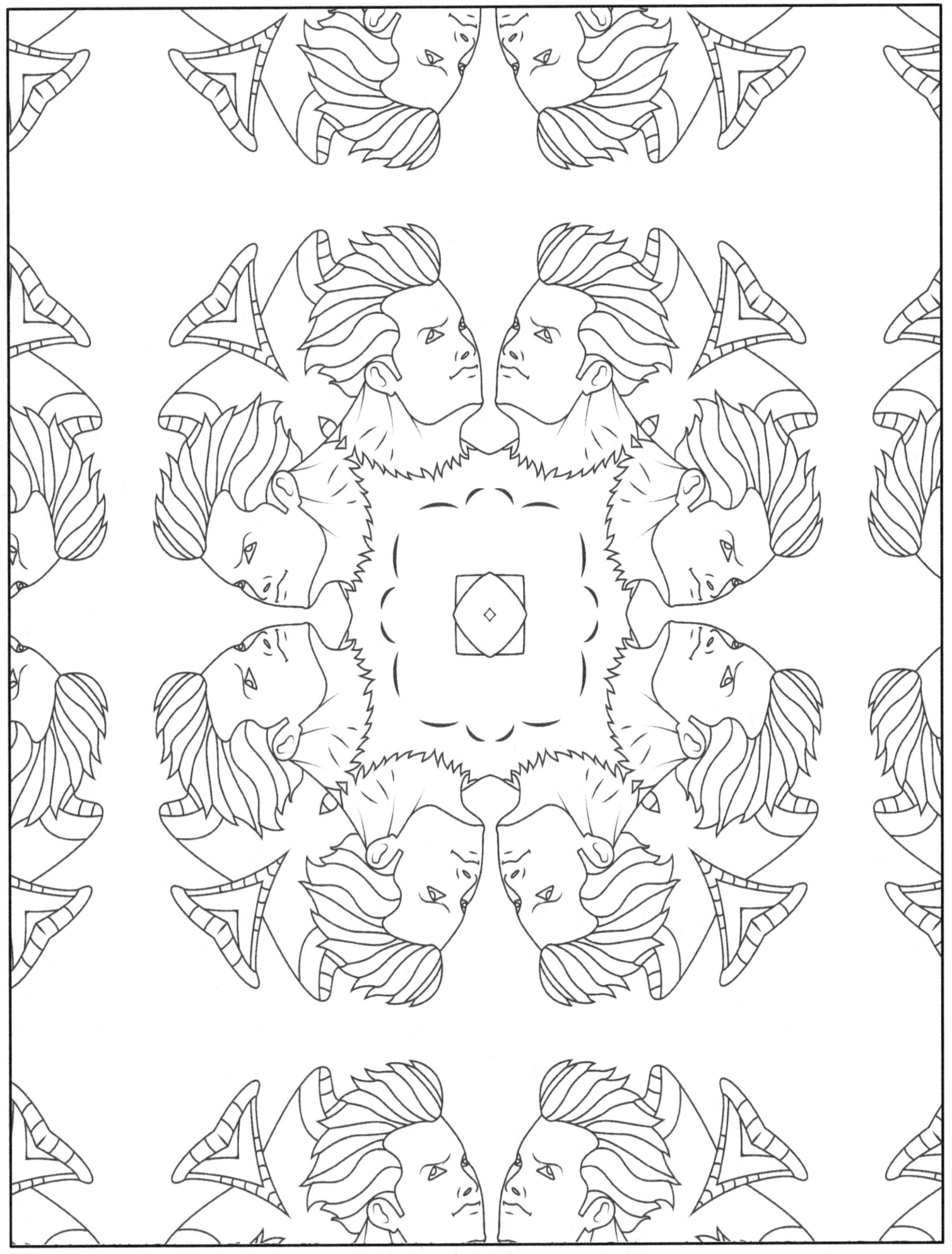

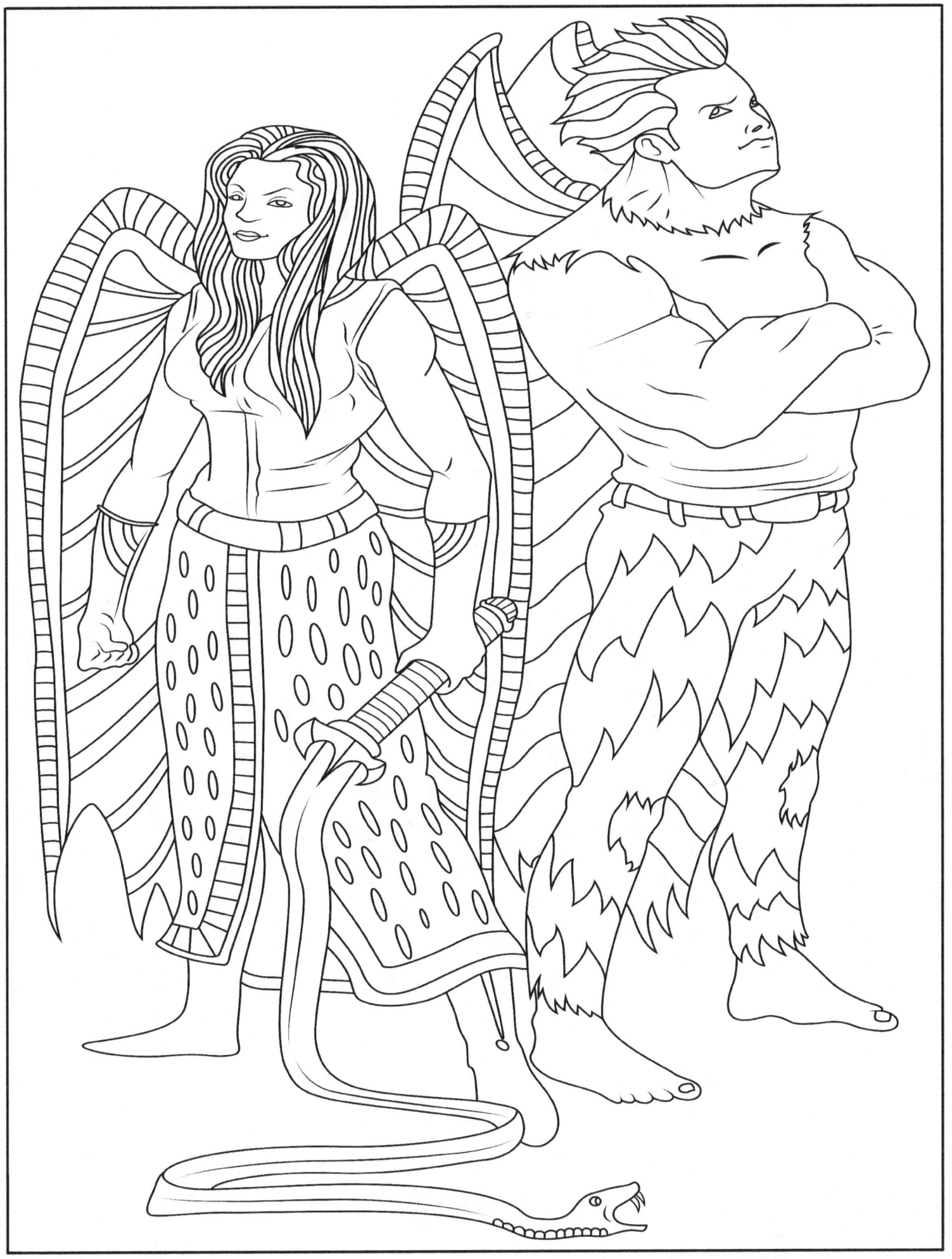

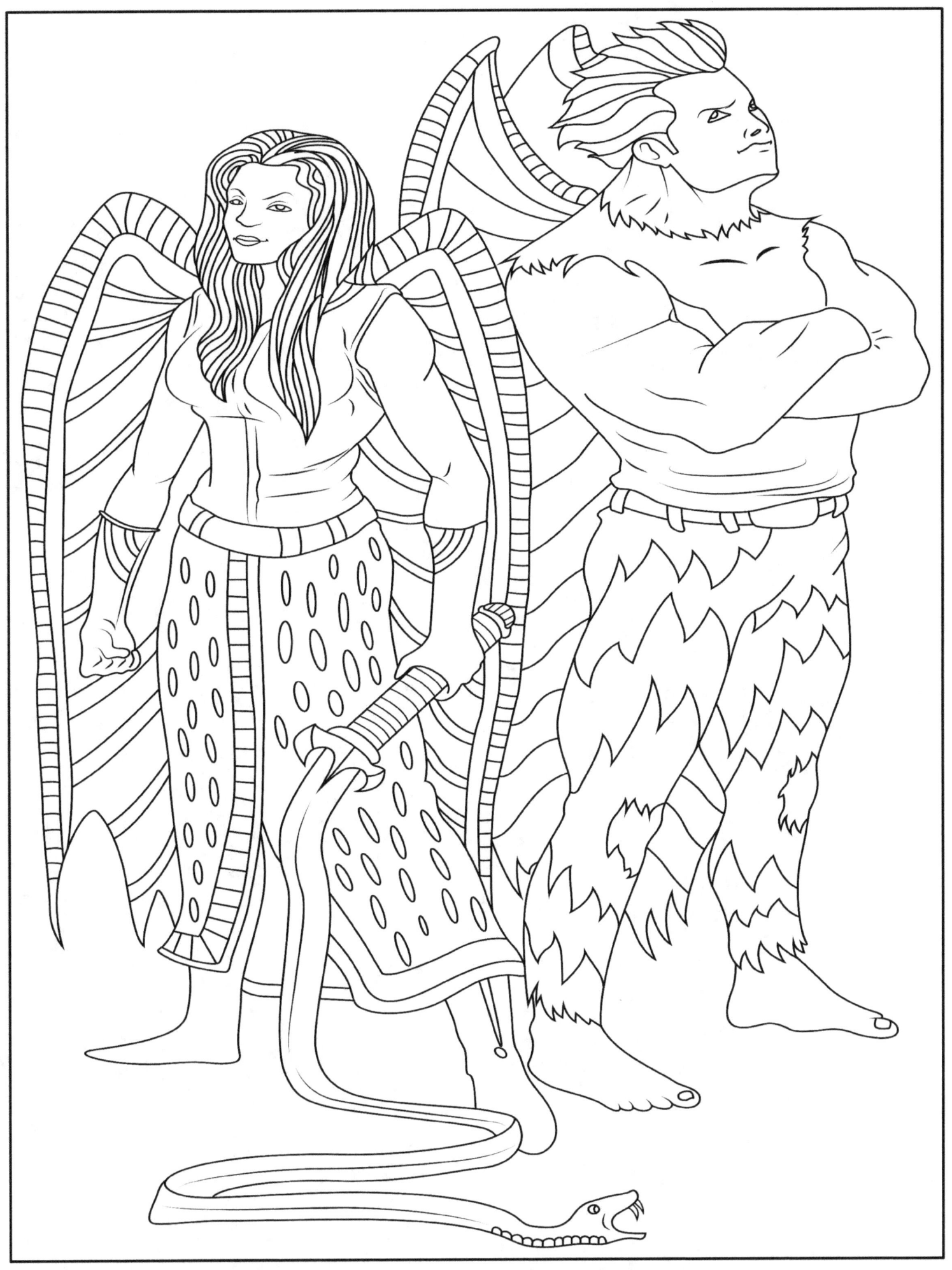

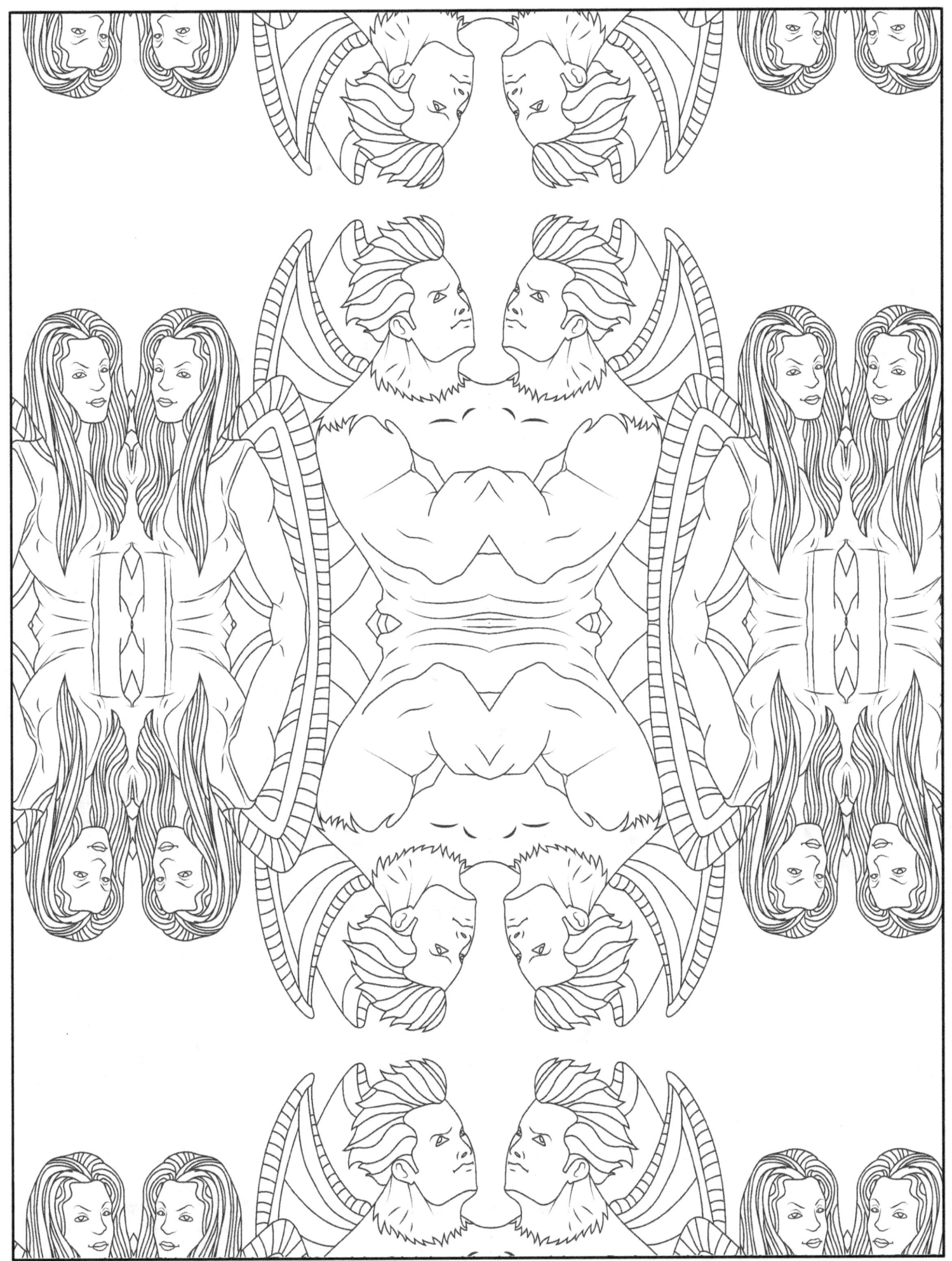

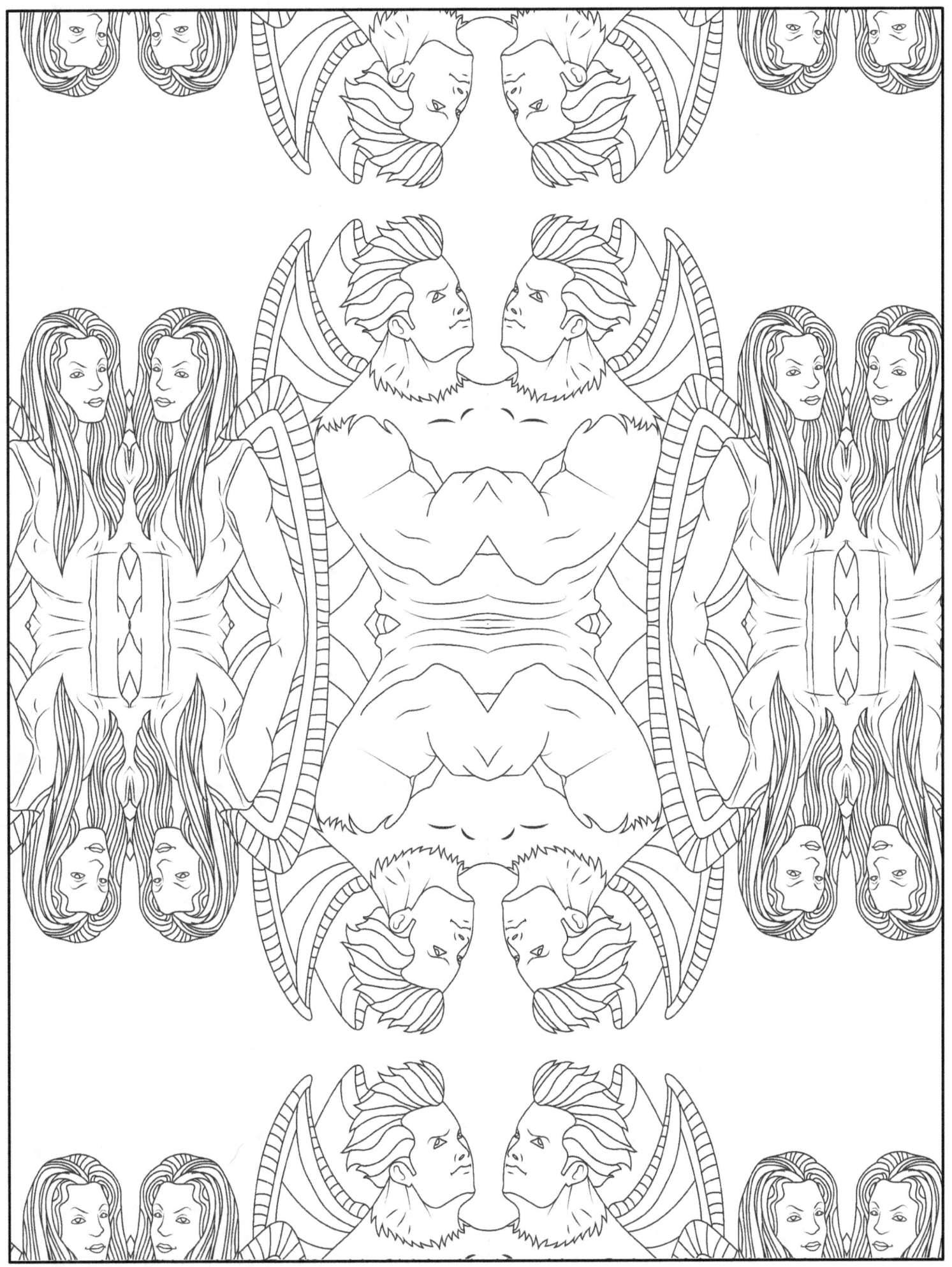

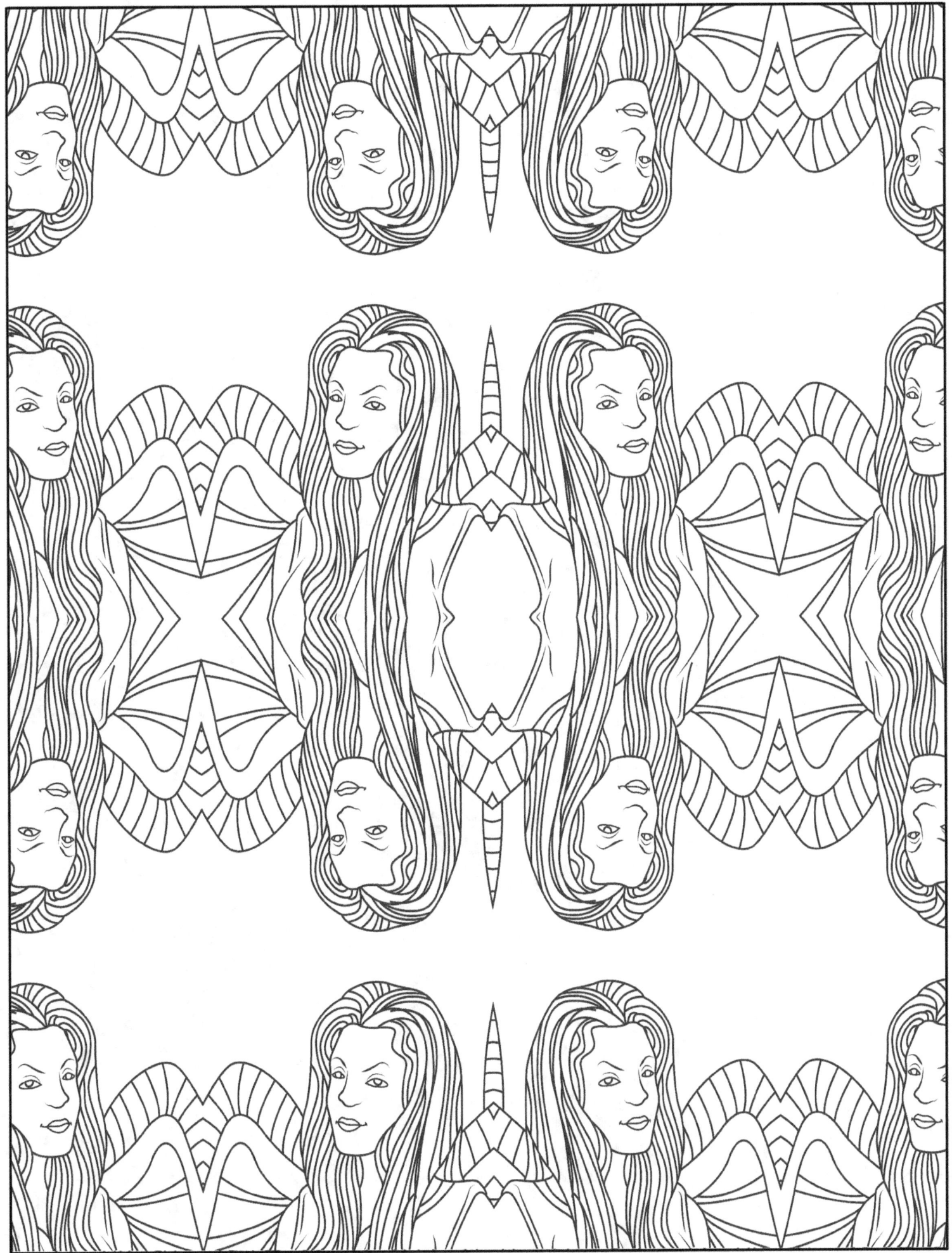

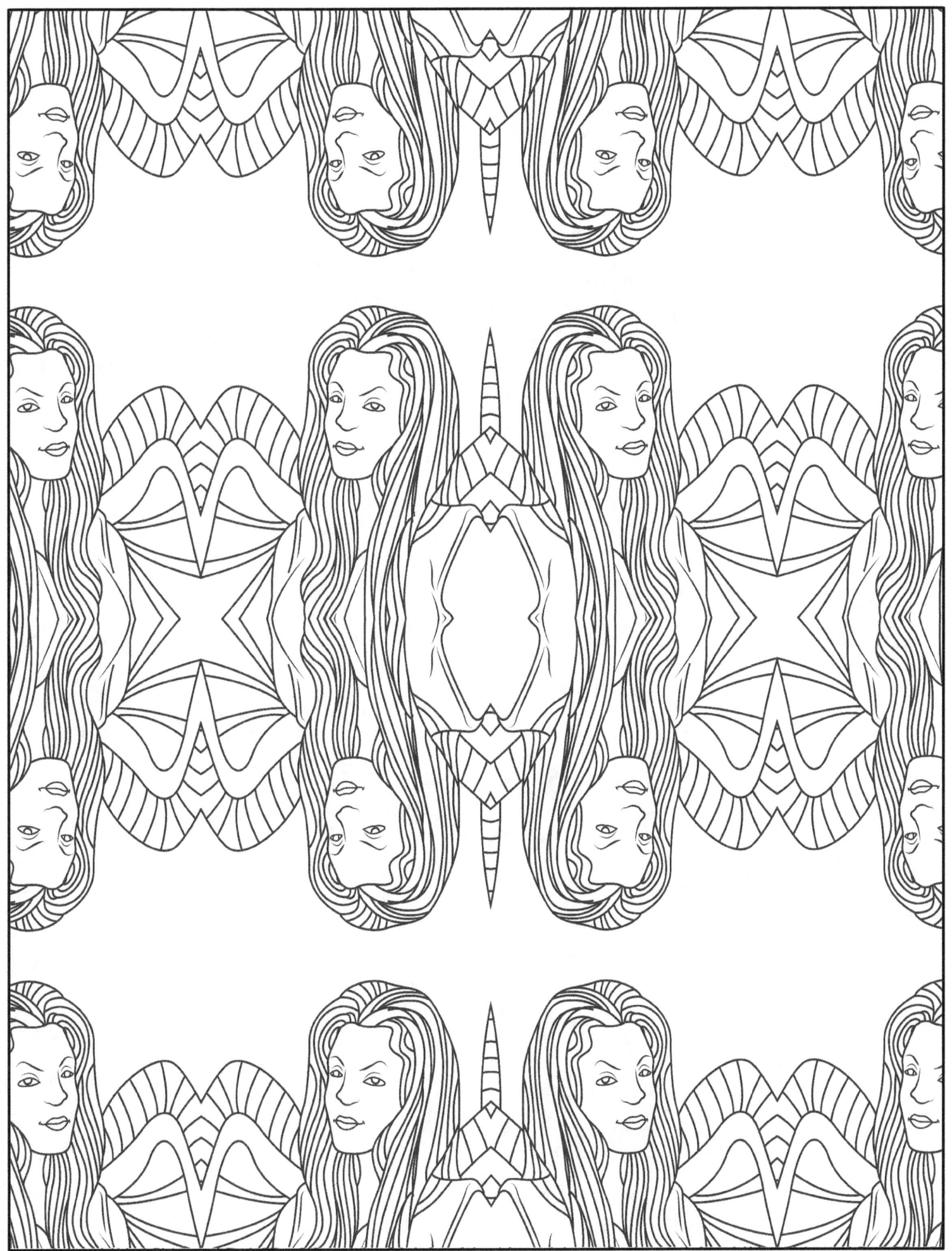

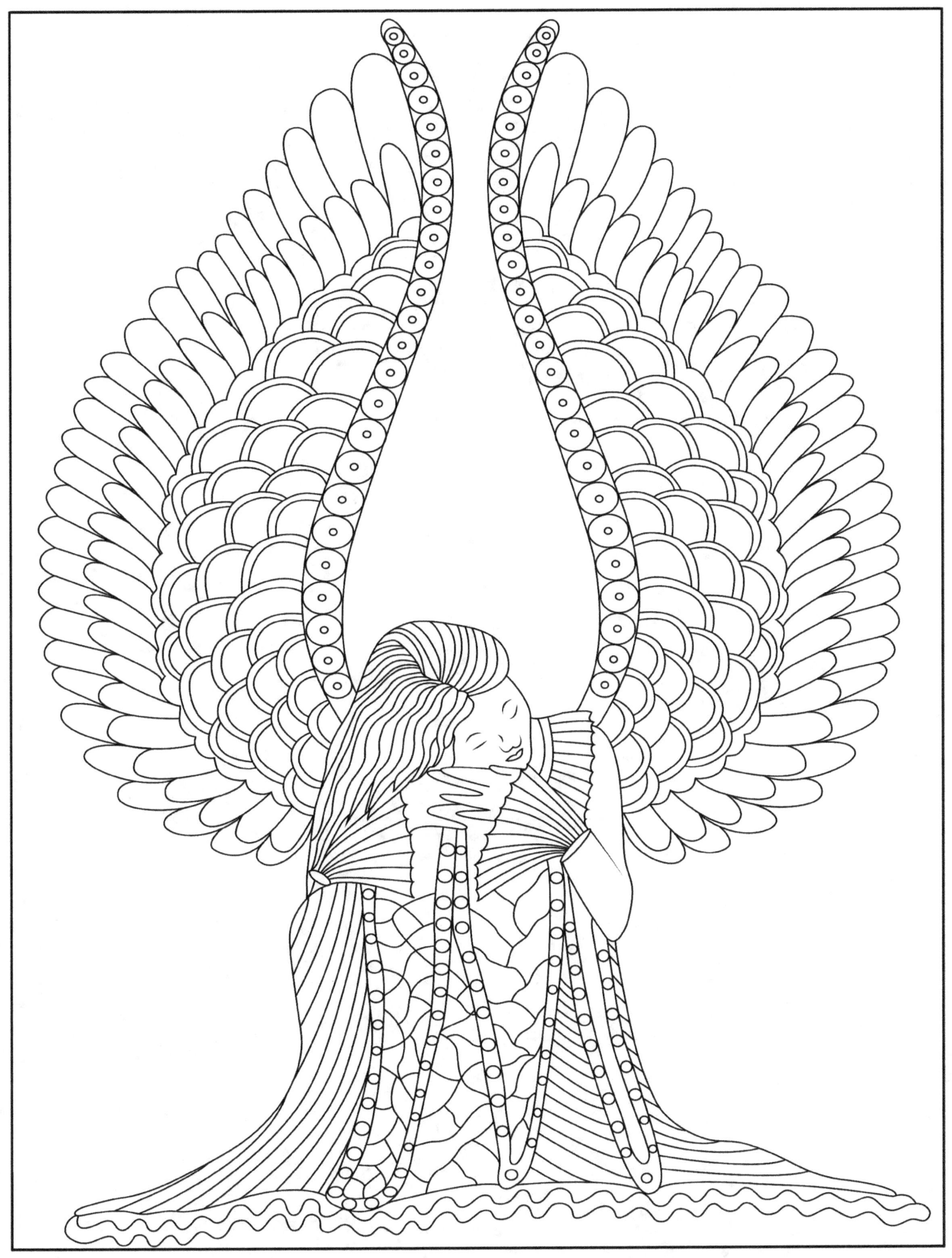

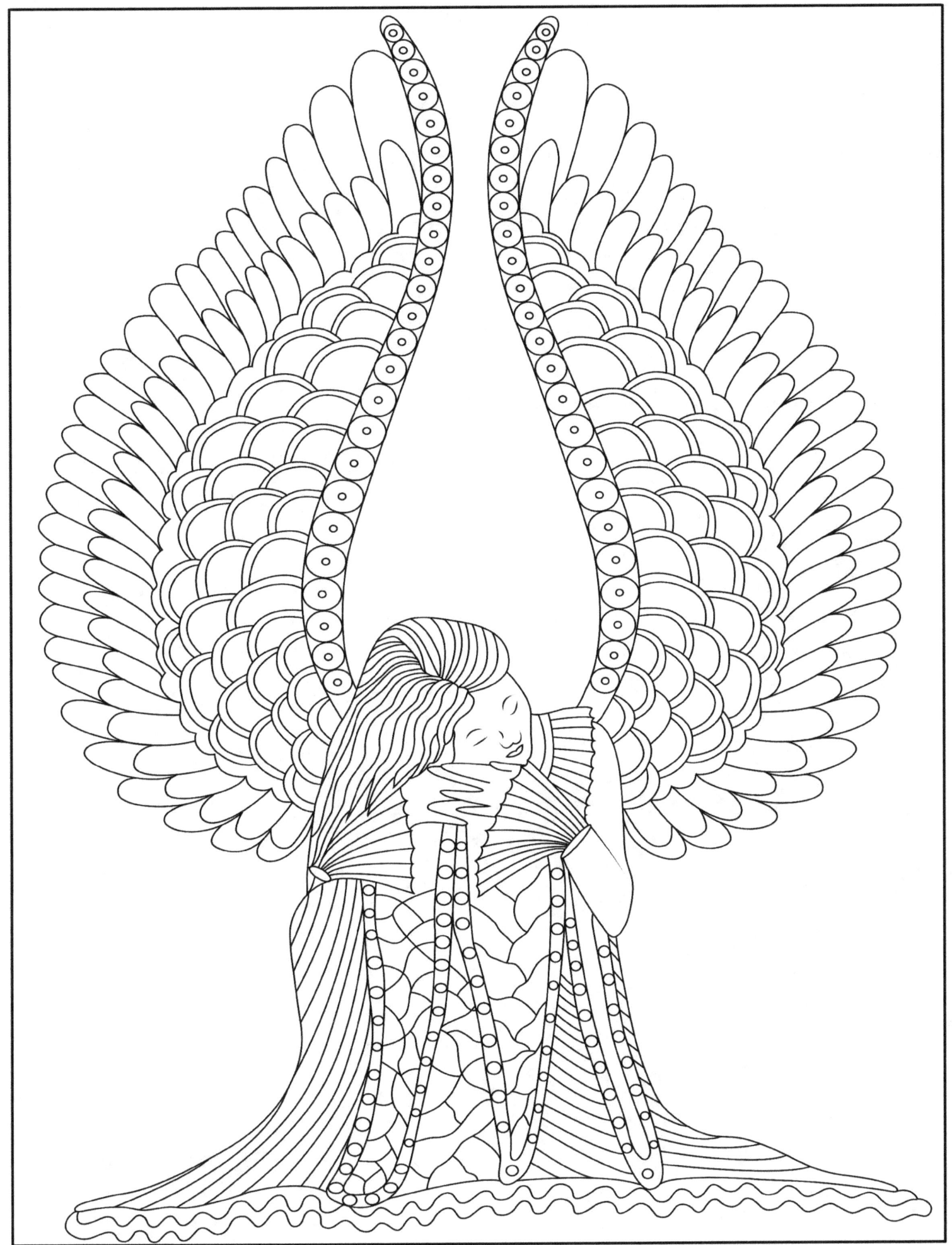

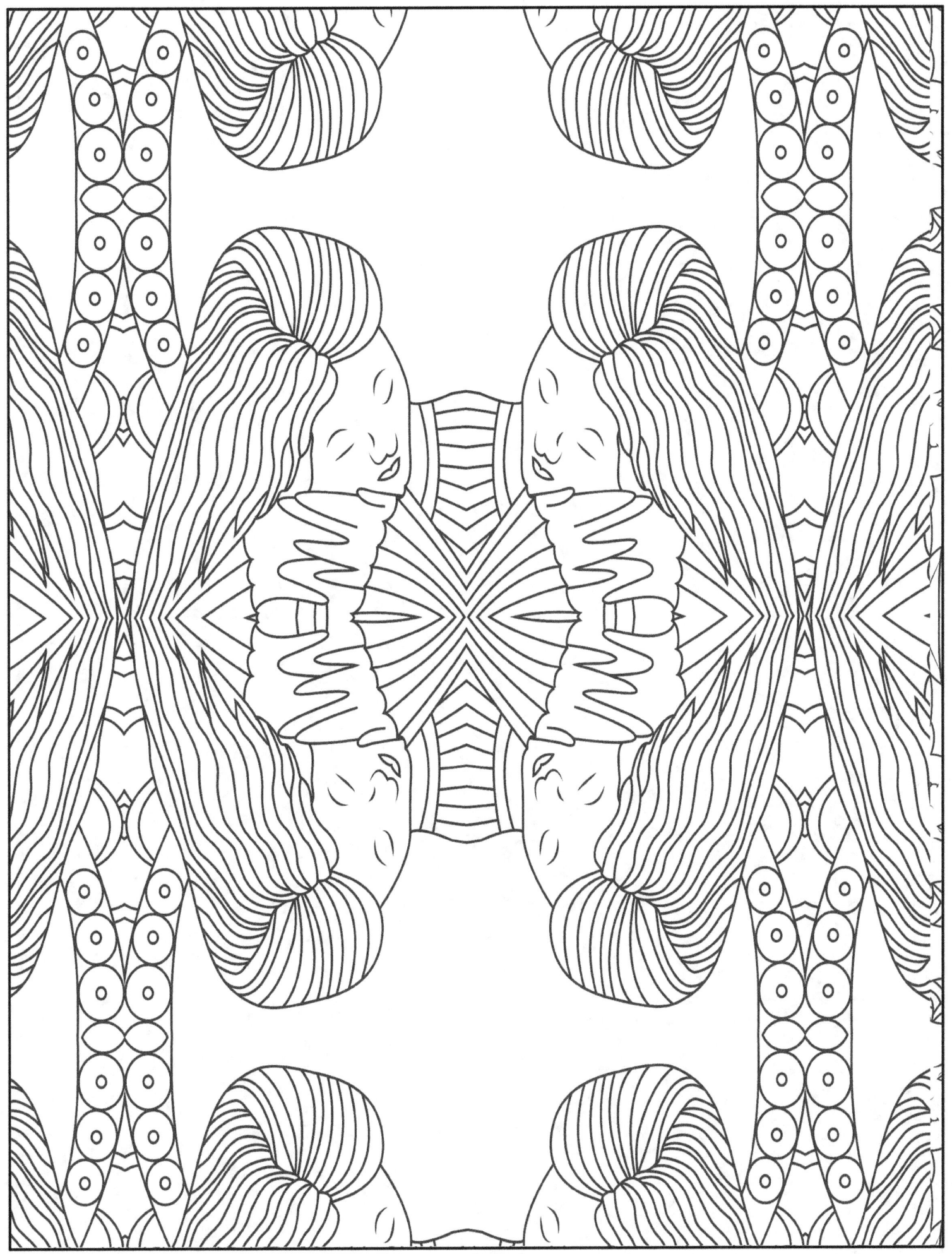

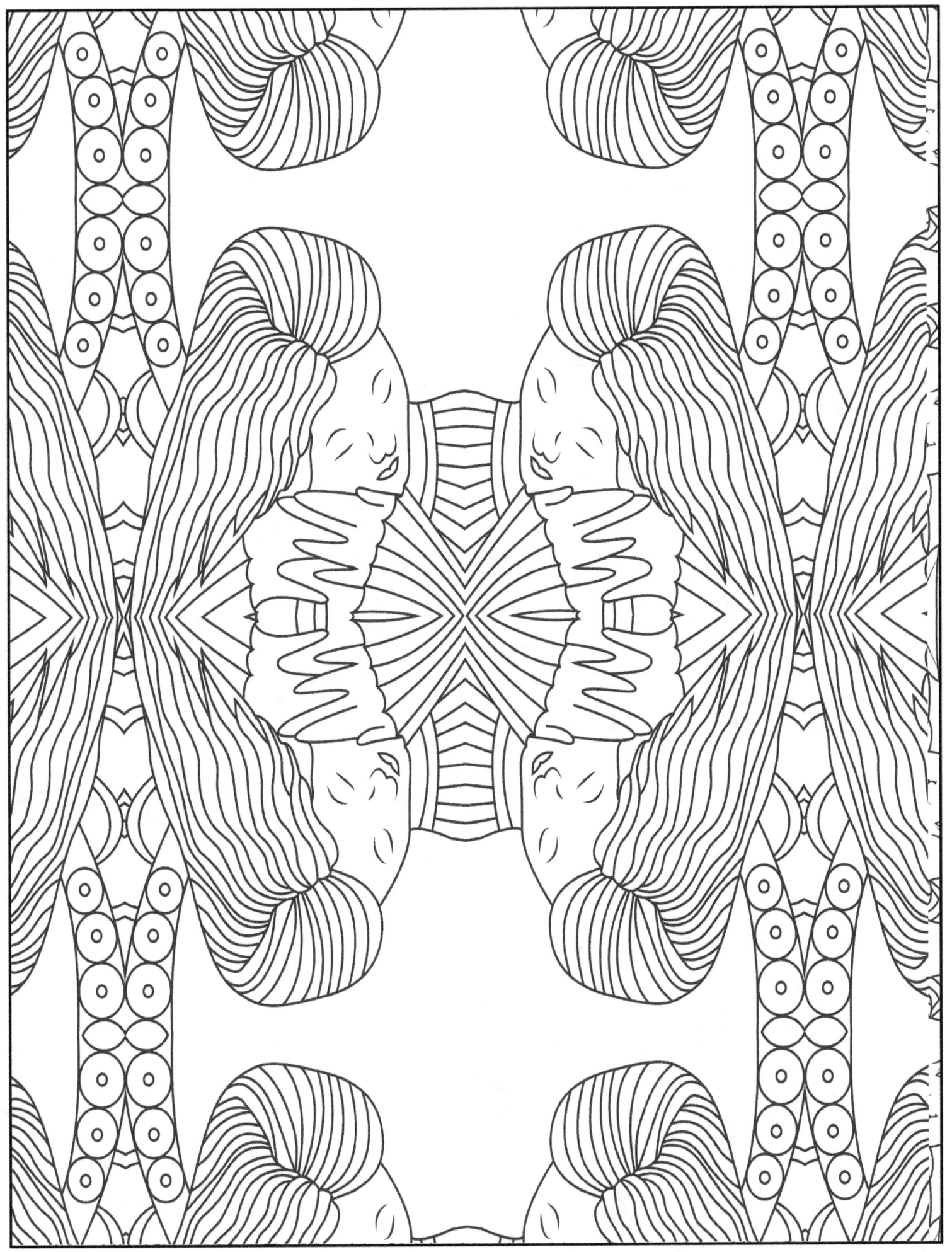

www.ingramcontent.com/pod-product-compliance
Lightning Source LLC
Chambersburg PA
CBHW081149180526
45170CB00006B/2003